D1479367

SO-BVV-883

Seuil · HISTOIRE DE L'ART · Paul Cox

C-206 · The Forgotten Museum · on the future of art · VIKING/COMPASS

Om on Ra · Victor Pelevin

Apollinaire · ALCOOLS · CAL 121

A FIELD GUIDE TO ROCKS AND MINERALS · POUGH · HMCO

FLOWERS OF EVIL · A SELECTION · BAUDELAIRE · ND PAPERBOOK 71

LES FEMMES DE PARIS · PAR LEANNE

GILBERT & GEORGE · capc Musée d'art contemporain de Bordeaux

Raymond Pettibon · Chimera Press

THE ADVENTURES of ACHILLES JONES · by JOHN BENNETT · T.S.

REVEALING ILLUSTRATIONS

CASA VOGUE · SUPPLEMENTO AL NUMERO 622 DI VOGUE ITALIA · GIUGNO 2002
Watson Guptill

Ute Behrend Girls, Some Boys and Other Cookies

ROSES OF THE WORLD IN COLOR
McFarland
H.M.Co.

1001 AFTERNOONS IN CHICAGO · BEN HECHT
COVICI-McGEE

THE ULTIMATE GUERILLA
TOM PAGON

THIS NOT THAT John Baldessari

F. SCOTT FITZGERALD
THE CRACK-UP
NDP757

THE WANDERER
ALAIN-FOURNIER
ANCHOR A 14

FRANZ KAFKA
AMERIKA
ANCHOR A 49

WOMEN OF PARIS

Stephen Crane: stories and tales
VINTAGE V-10

Borges LABYRINTHS
NDP

nausea jean-paul sartre
NDP82

ROBERT LOWELL
NOTEBOOK
NOONDAY

Ethan Frome

Wharton

JUBILEE

T. S. ELIOT | Collected Poems

Faber

HARVARD COLLEGE CLASS OF 1952

25th Anniversary Report

1977

THE LONELY ONES — WILLIAM STEIG

DELL, SLOAN AND PEARCE

Hammond's Complete WORLD ATLAS

C.S. HAMMOND & CO.

THE GANZFELD / 3

THE LAMP 1983

04334 4 NEW POCKET $1.25

Rock and Other Four Letter Words

BANTAM BOOKS

MASCULINE FEMININE BY JEAN-LUC GODARD

3

A FIELD GUIDE TO THE BIRDS

PETERSON

HOUGHTON MIFFLIN CO.

Found Poems ♗ by Bern Porter

SOMETHING ELSE

MARTIN ASSIG

ZEICHNUNGEN 1992-99

HIPGNOSIS · WALK AWAY RENE

PAPER TIGER

AMERICA'S FAVORITES

Rosemary's Baby

Kay & Marshall Lee

PUTNAM

THOMAS MANN

DEATH IN VENICE

SPECK

Herlman

Against History, Against Leviathan!

Powers

ADVANCED TECHNIQUES OF HYPNOSIS

STUNT WORK AND STUNT PEOPLE

EMMENS 791.43 Emm

H.L.Mencken

Prejudices: A Selection

Vintage V/68

BOOKS, LIBRARIES AND YOU

Third Edition

Boyd Raisden

Mott Memmler

SCRIBNERS

j028
B
1965

Franny and Zooey JD Salinger

LONDON

WARD LOCK

WHO DO YOU THINK YOU ARE?

ALICE MUNRO

Nelson

2 Mr. Whiskers

SCHIRMER/MOSEL

DELL

VINT
V-3

FRESH DIALOGUE FOUR

New Voices in Graphic Design

SPINE

Edited by Véronique Vienne
With Séamus Mullarkey

PRINCETON ARCHITECTURAL PRESS
AMERICAN INSTITUTE OF GRAPHIC ARTS NEW YORK CHAPTER
NEW YORK, 2004

PUBLISHED BY
PRINCETON ARCHITECTURAL PRESS
37 EAST SEVENTH STREET
NEW YORK, NEW YORK 10003

FOR A FREE CATALOG OF BOOKS, CALL 1.800.722.6657.
VISIT OUR WEBSITE AT WWW.PAPRESS.COM

EDITING: NICOLA BEDNAREK
DESIGN: DEB WOOD

SPECIAL THANKS TO: NETTIE ALJIAN, JANET BEHNING,
MEGAN CAREY, PENNY (YUEN PIK) CHU, RUSSELL FERNANDEZ,
JAN HAUX, CLARE JACOBSON, MARK LAMSTER, NANCY
EKLUND LATER, LINDA LEE, KATHARINE MYERS, JANE
SHEINMAN, SCOTT TENNENT, JENNIFER THOMPSON, AND
JOSEPH WESTON OF PRINCETON ARCHITECTURAL PRESS
—KEVIN C. LIPPERT, PUBLISHER

LIBRARY OF CONGRESS CATALOGING-IN-PUBLICATION
DATA

FRESH DIALOGUE FOUR : NEW VOICES IN GRAPHIC
DESIGN / EDITED BY VÉRONIQUE VIENNE ; WITH SÉAMUS
MULLARKEY.—1ST ED.
 P. CM.
ISBN 1-56898-463-4
1. BUCHANAN-SMITH, PETER GORDON. 2. FULFORD,
JASON. 3. SHAPTON, LEANNE. 4. COMMERCIAL ART—NEW
YORK (STATE)—NEW YORK. 5. GRAPHIC ARTS—NEW YORK
(STATE)—NEW YORK. 6. PUBLISHERS AND PUBLISHING—
NEW YORK (STATE)—NEW YORK. 7. ART PUBLISHING—NEW
YORK (STATE)—NEW YORK. 8. DESIGNERS—NEW YORK
(STATE)—NEW YORK—INTERVIEWS. I. TITLE: FRESH DIA-
LOGUE 4. II. VIENNE, VÉRONIQUE. III. SÉAMUS
MULLARKEY.
 NC998.5.N72 N485 2004
 741.6/092/27471 21
 2003063159

contributors

PETER BUCHANAN-SMITH

JASON FULFORD

LEANNE SHAPTON

moderator

PAUL SAHRE

time

15 MAY 2003

location

FASHION INSTITUTE OF TECHNOLOGY,
NEW YORK CITY

contents

FOREWORD. 11

by Emily Oberman and Nicholas Blechman

CHAPTER ONE: *Beginnings.* . 12

CHAPTER TWO: *Money, or, How You Get Paid
to Continue Doing the Things That You Love.* 56

CHAPTER THREE: *Books and Publishing.* 98

CREDITS. 142

What is Fresh Dialogue? It is a night of looking at the work and listening to the words of talented, young designers whom a lot of people may not have heard of (yet). Over the years, Fresh Dialogue has had an extraordinary history of featuring extraordinary people (Art Chantry, Paula Scher, and Rick Valicenti to name but three). Staying fresh for twenty years is a pretty difficult task (this is the twentieth AIGA/NY Fresh Dialogue event), but we (and by we, we mean all the board members who have given their time and energy to AIGA/NY over all these years) have made a priority of trying to stay true to the ever-shifting meaning of the word "fresh."

After a few years of highlighting multimedia work, this year we decided "fresh" meant self-authorship and a passion for the printed page. The speakers were Peter Buchanan-Smith, Jason Fulford, and Leanne Shapton. They all love books (which is why they've published so many and made them a large part of their lives). They also love art, politics, humor, and music (which is why they included the live music of Timber! in their evening). Along with moderator and Fresh Dialogue alum Paul Sahre, they created an evening full of interesting work, dialogue, and (very loud) music.

Each one of these three presenters can move effortlessly from one role to another within a project. They write, they design, they photograph, they illustrate, and they edit. They also publish books, coordinate distribution, and then promote their titles. They are very independent, and very busy.

We hope this book captures some of the spirit of the evening, which was filled with inspiring anecdotes, images, and words from these talented people. We also hope this book lives up to their (very high) standards.

As always we are grateful to Princeton Architectural Press for the chance to recreate this event in print.

EMILY OBERMAN
President, AIGA/NY 2002–2004

NICHOLAS BLECHMAN
Fresh Dialogue Chair 2003
Board member, AIGA/NY 2002–2004

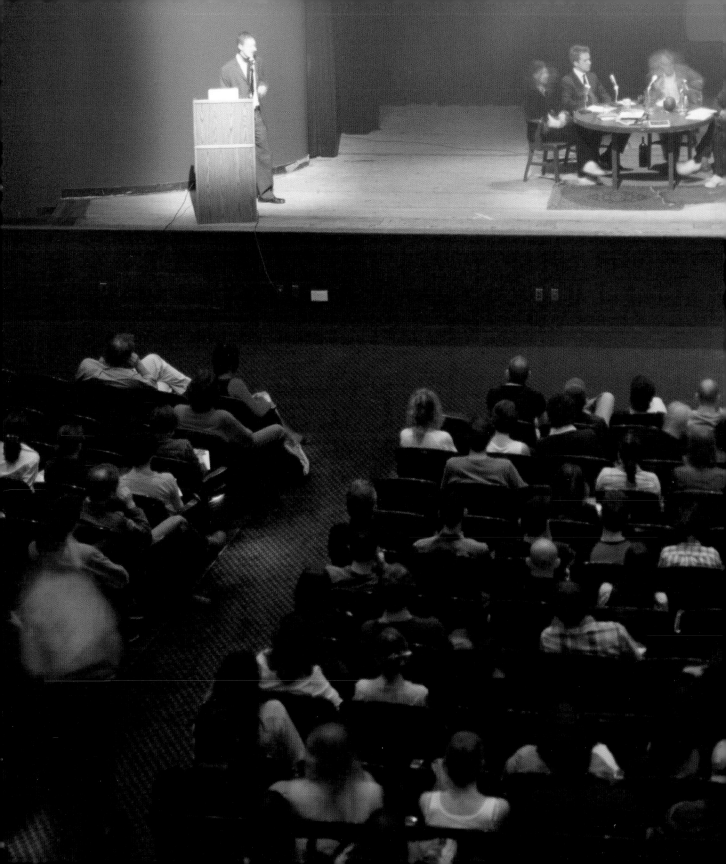

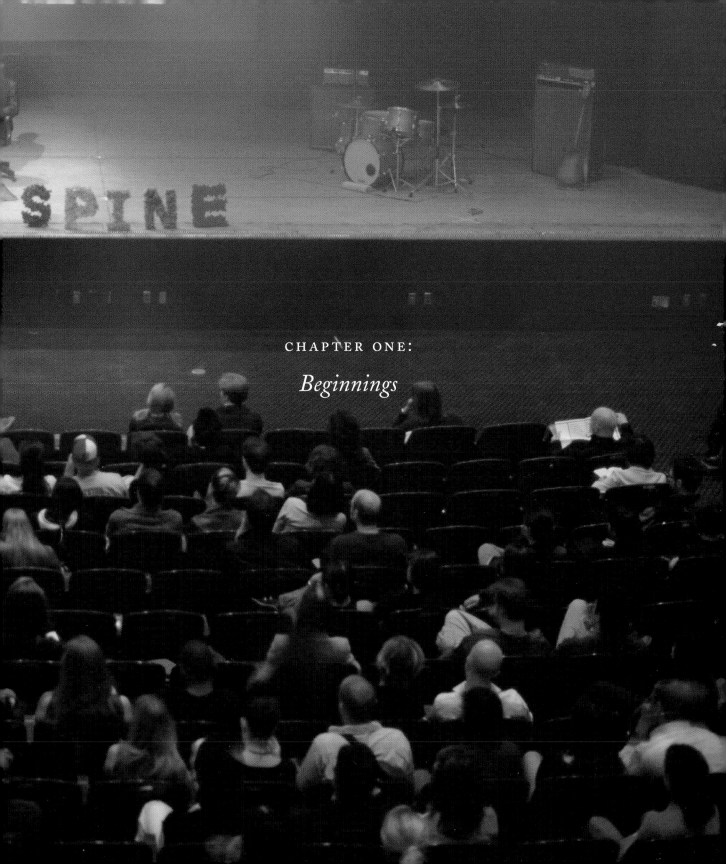

CHAPTER ONE:

Beginnings

[*dense fog moves across the stage, where Timber! is playing, rock music fades, subdued background conversation*]

PAUL SAHRE. Hello, and welcome to Spine, this year's installment of Fresh Dialogue. It's my pleasure to introduce Peter Buchanan-Smith, Jason Fulford, and Leanne Shapton.

Peter Buchanan-Smith, a.k.a. Angus McWilton, is an art director, graphic designer, author, and publisher. He is a graduate of the Master of Fine Arts program at the School of Visual Arts in New York City and the former art director of the *New York Times* Op-Ed page. Most recently, he cofounded the design firm and publishing company Monday Morning.

Jason Fulford is a photographer, graphic designer, and publisher. He is an American who lives in New York City; Scranton, Pennsylvania; Los Angeles; Beijing; Budapest; Toronto; Bombay; Seoul; and a bunch of other places. And Jason knows the band that is playing tonight, Timber! Timber! is an instrumental band from New York. Logan Kass on bass. Mike Friedrich on guitar. Phil Kennedy on drums.

Leanne Shapton is an illustrator, art director, graphic designer, and publisher. She and Jason have known each other since 1993. They met in a film class at Pratt Institute and actually dated for a while. They split up but remain best friends. While their careers have taken very different paths, they have often collaborated and hired each other. This led to the formation of their nonprofit imprint, J&L Books, in 2001.

Peter met Leanne through Nicholas Blechman in 1998, although they have never worked together, or dated—but they are both Canadian. Peter and Jason did not know one another before being asked to participate in this year's Fresh Dialogue, so, Jason, Peter, Peter, Jason...

Tonight we hope to explore some of the similarities, connections, and motivating factors that these three talented and independent people share.

Peter

BUCHANAN-SMITH. As Paul mentioned, I'm from
 Canada. But about ten years ago I moved to Ireland
 (because I was in love with Irish culture at the time),
 where I basically introduced the computer.
SAHRE. You introduced the computer to Ireland!?
 [*laughter*]
BUCHANAN-SMITH. Yes! I literally introduced the
 first computer to Ireland. That one computer spawned
 into three. And those three spawned into a contract to
 publish a national telephone directory for an Irishman
 called Michael Donovan.

1

 Here you see three of our employees, furiously
 typing away, copying all of the information from one
 phone book and putting it into our phone book.
 Everything was going really well, until Michael
 Donovan decided to stop paying us. We soon discov-
 ered that we were not the only ones he hadn't paid.
 After a failed attempt at finding Michael, we were
 packing up, when these two scary looking guys came
 into our office. They said, "We hear, boys, that
 Michael Donovan owes you some money. How much
 does he owe you?"

 We said, "He owes us a lot. Why do you ask?"
 "'Cause we can get some of it back for ye."
 "How would you do that?"
 "Well, you know his brother? He is a rich execu-
 tive of Shell Oil. What we do is, we hold Michael
 hostage. And then we get the money back. Don't
 worry, boys, we give you half, we take the other half."

 We said, "You can just take everything." And we
 left. We left the country.

 We didn't hear anything until two years later,
 when we learned that Michael Donovan had turned
 up dead in a ditch.

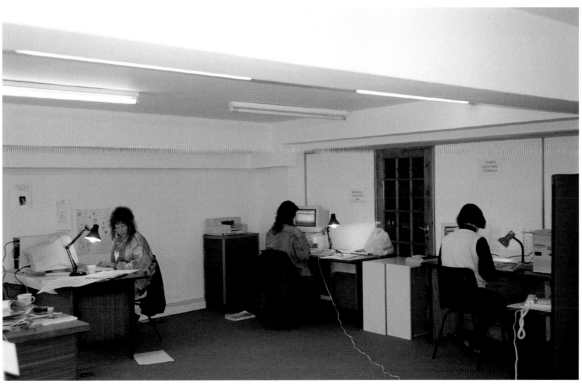

1

I moved back to Canada and decided I wanted to work in publishing in a more controlled and safer environment. So I attended the Radcliffe publishing course in Cambridge, Massachusetts (now the Columbia publishing course) and afterwards moved to New York, the city of my dreams. I got a job at Farrar, Straus and Giroux designing the interiors of books and their cases. As it turned out, Farrar, Straus and Giroux was a bit of a dead end for me, and I decided to enroll in a Masters of Fine Arts program.

2

MAN IS NOT ALONE

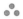

A Philosophy of Religion

ABRAHAM JOSHUA HESCHEL

THE NOONDAY PRESS
Farrar, Straus and Giroux / New York

MAN IS NOT ALONE

GOD IN SEARCH OF MAN

■ ■ ■ ■ ■

A Philosophy of Judaism

ABRAHAM JOSHUA HESCHEL

THE NOONDAY PRESS
Farrar, Straus and Giroux / New York

The only one in New York that excited me was a new program that Steven Heller was starting at the School of Visual Arts (SVA). At the core of his program was the development of a thesis project that would be viable in the real world. As I'm entrepreneurial rather than theoretical by nature, this was a big appeal. The fact that it was a brand-new, untested course was also attractive. So I enrolled in the SVA graphic design MFA program.

3

As one of my first projects at the SVA I printed about five thousand stickers that said, "Missing: God. If you know the whereabouts of God, please contact (212) 465-7550." I put up all five thousand stickers across the city of New York and got about three hours worth of material—over a hundred phone calls. I had little social and no religious motive for this. I just wanted to see what sort of immediate reaction an idea or a design could provoke from an audience. I have some of those phone messages here tonight and will play them for you.

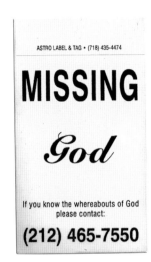

3

"This is not my message. It's God's message. And his message is very clear."

"God bless you, my friend, and I continuously pray that you will find God in your own way. God isn't lost. You are."

"God! God! You know, he's drowning in the Hudson River, you gotta help, you gotta save him before he drowns."

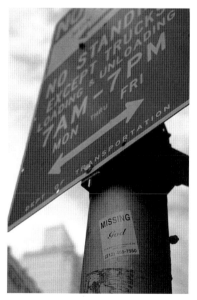

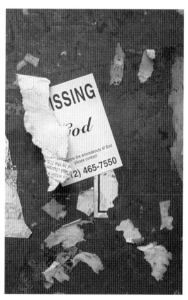

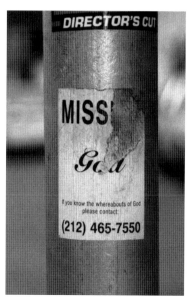

At the same time, I was working on a magazine project for a class at SVA. Our magazine was called *Lost and Found*, and I took pictures of the New York subway's Lost and Found department for it. This project told me how much the act of curating has to do with design: it was a small revelation to see how subway workers had curated and organized parts of the Lost and Found. They obviously cared very much for the contents—the lost souls of the subway—of this collection. Here you see one of the curators (an employee of the MTA Lost and Found).

I was beginning to take aim on a thesis that would have something to do with "the everyday." I was influenced in this by Marcel Duchamp, Joseph Cornell, and the 1960s Fluxus Group, all of whom incorporated a significant element of common objects into their art. I found concentrating on my immediate surroundings a healthy constraint and started documenting curious events, stories, and collections.

Extending this notion to the realm of sports journalism, I became interested in a new burgeoning sport going on in America. So, equipped with a high-power zoom lens, I spent a weekend in upstate New York photographing the topsy-turvy world of lawn mower racing.

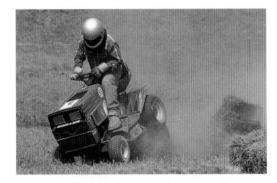

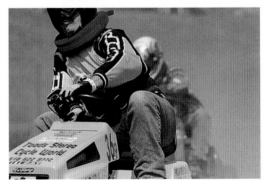

4

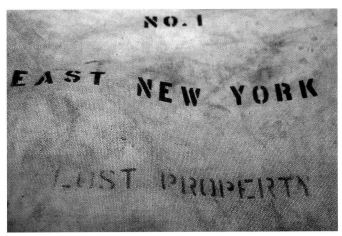

5

6

While at the SVA, in what turned out to be a premonition of things to come, I got a call from Nicholas Blechman. I had worked part of one summer for him at the *New York Times*. He was now the art director for the Op-Ed page of the *Times* and asked me if I would do an illustration for the Letters to the Editor section. This was on a Friday afternoon. I was supposed to hand it in Monday at 5 P.M. I slaved furiously all weekend on this thing. Come Monday evening, I was told that it had to be changed—and so, a weekend's work had to be redone in five minutes.

7

who have no knowledge of local treatment norms develop medical treatment protocols.

Much of the resentment that physicians have toward the managed care industry has to do with the individual antitrust laws must be changed to allow negotiation among equals and reach an equitable compromise.

AVI BARBASCH, M.D.
New York, Oct. 18, 1999

Inspiration Born of New Brain Cells

To the Editor:

Your Oct. 15 front-page article "Brain May Grow New Cells Daily" raises fascinating questions not only from a purely scientific perspective but from a philosophical one as well. The human brain — or shall I say mind — exists today exactly as it has for many thousands of years. And while scientific findings that increase our awareness of brain function may well lead to medical advances, these studies' effects on behavior may be at least as significant for the human species.

All of us have attributed a lost thought to age, but how often do we attribute a new idea to a new crop of neurons taking hold on our cortex? The implication is that simply being aware of our potential to build circuitry may lead many of us to revel in the possibilities and stimulate our minds more relentlessly and passionately. That possibility is exciting.

FOR BEST RESULTS: STIMULATE FREQUENTLY, AVOID NEGLECT

Peter Buchanan-Smith

Mental pliancy may not change, but inspiration is forever malleable.

MATTHEW LAKENBACH
Fairfield, Conn., Oct. 15, 1999

Protecting U.N. Workers

To the Editor:

You are right to trumpet the need to improve the protection of United Nations civilian workers (editorial, Oct. 17). But your prescription — more resources for security training — is insufficient. What is needed is an international campaign to prosecute those who attack aid workers. A framework for this campaign could be provided by the 1994 Con-

Holocaust Victims

To the Editor:

Re "G.I.'s Are Called Looters of Jewish Riches" (front page, Oct. 15):

The photograph showing a crate of wedding bands seized by the Nazis is riveting. Consider that each band in the heap represents two human lives standing under a wedding canopy, smiling and imagining a future. The rest is incidental.

Jason

FULFORD. My parents wanted me to learn "job skills" in
college, so I wasn't allowed to study photography,
which would have been my first choice.

[*laughs*]

I ended up studying graphic design and art direction
at Pratt Institute in New York. I went straight out of
school into a small design studio, designing video
boxes—the kind you'd see in Blockbuster Video.
Here's one for a film called *Night Shade*.

8

At some point during the second year of this job,
I started itching for some freedom. I needed to travel
and take pictures. So finally, after two years, I quit
my job and took off on a motorcycle for a few
months. The idea was to drive south, following the
Mississippi River from its headwaters in Minnesota
down to New Orleans.

Most photographers fall into one of two cate-
gories: they are sculptors or collectors. The sculptors
start from scratch and build a scene, then photograph
it. The collectors photograph things in their environ-
ment—things they stumble on. They collect these
images and literally take pictures home with them—
like yard-sale shopping.

I'm a collector, and I started collecting images of
the Midwest. Riding my motorcycle for three months
felt like sitting on a stationary bike in front of a large-
screen TV with images flying past me. As I captured
these images, I often felt like I was stealing all the
beautiful things from the small towns I passed
through. I felt like a thief.

8
9

9

SAHRE. You mentioned going to design school and your parents' aversion to you studying photography. Were you trained as a photographer in any way? Or was this intuitive?

FULFORD. I started taking pictures in high school. I won Pratt's "National Talent Search" with photography, and they gave me a full ride. In school, I continued taking pictures as I studied other subjects. After I graduated and while working as a graphic designer, I would go on weekend road trips to shoot. During the week, I worked in the daytime and stayed up late in my darkroom at night.

One of Gertrude Stein's friends once said something like, "If you don't bust your ass when you're twenty, no one will love you when you're thirty." By the time I was ready to quit the design job, I had an OK portfolio of photographs to show around. First, I went after publishing houses, trying to get my pictures onto book jackets. I sought out designers whose work I respected. Magazines followed, and then advertising jobs. I had no formal training with lights or professional photo gear, so I would hire really good assistants and learn from them.

10

06.000

Pennsylvania
Ohio
Indiana
Wisconsin
Minnesota

JASON FULFORD

Scranton 1999 summer

Oklahoma 1997

29.000

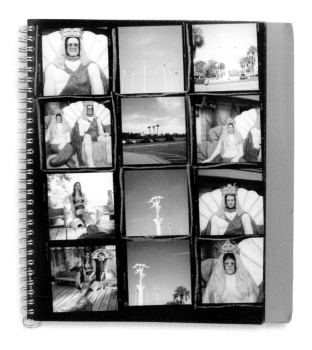

07.000

Florida
Georgia

11 This was somewhere in Louisiana. I pulled up to a motel, and as I was unloading the bike, this guy walked up to me. Looking the bike up and down, he said, "Nahce bahke!" I said, "Thanks." And he went, "If you don't take that inside, somebody's gonna git it." The next thing I know, he is helping me bring the bike up a flight of stairs and through the hallway, right into my motel room. I slept next to it that night with an Elvis movie on TV!

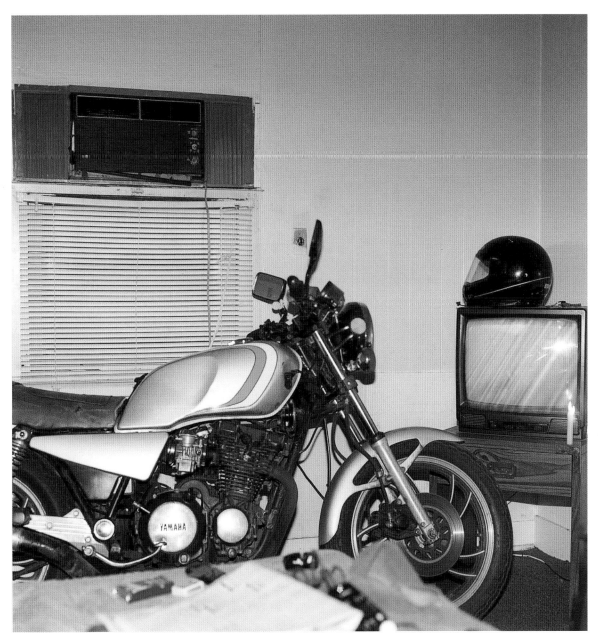

13

My work is influenced more by books, music, and found objects than by photography. I've always admired old postcards, especially those that present mundane subject matter in a very straightforward way. They almost become metaphors: you can use your imagination to bring meaning to these images.

In the documentary *My Best Fiend*, German filmmaker Werner Herzog talks about his film *Fitzcaraldo* and why he made it. He says he heard this true story about a man who pulled a ship over a mountain and he knew immediately that he had to make a movie about it—because it was such a great metaphor. The interviewer asks, "A metaphor for what?," and Herzog says, "I don't know, but it was such a great metaphor. I had to make the movie."

12

I would come back from my trips with boxes of images and had to figure out a process to edit them. In a bookstore in Atlanta I found a book by the German photographer Ute Behrend entitled *Girls, Some Boys and Other Cookies*, which taught me about juxtaposition: about how photographs can play off each other and affect the viewer's thoughts and trigger memories—the whole being greater than the sum of the parts.

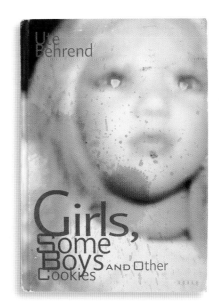

12

Greetings from **SOUTHERN CALIFORNIA**

NATIVES OF BAKER, CALIF.

13

14 I began organizing my pictures in pairs and
grids. I would cut up a set of contact sheets into indi-
15 vidual frames, lay them all out on the floor, and start
to arrange them. I found that this process was just as
16 stimulating as gathering the images in the first place.
There were just as many surprises and discoveries in
17 the editing and curating as in riding through these
weird towns. I found that collecting and editing were
18 equally important. When shooting, I never know how
the pictures will end up being used.

SAHRE. You know, we've talked about this before;
sometimes you could stare at two pictures for an eter-
nity and never find a connection between them—and
yet they still work out as a pair.

FULFORD. Yes, or you could come back to them a year
later and think something totally different. I usually
look for three layers in art. First is a purely physical
attraction. Second is a contextual connection. Third is
the "suggestion," the raising of a question without
giving away the answer. Theodor Adorno called it "the
potential for a solution." Roland Barthes referred to it
as the "obtuse meaning."

14

15

16

17

18

Leanne

SHAPTON. For me, a lot of what I do now started when
I was fourteen, and my dad gave me a book by the
illustrator James McMullan, who does the Lincoln
Center posters. I was fascinated by his work and
would copy his illustrations like crazy. I assumed that
he was dead, because he was famous and had a book
about his life's work.

I wound up going to Pratt Institute, which is
where I met Jason. One day, when I was really bored,
I flipped through the New York City phone book
and looked up James McMullan, just for fun. Sure
enough, his name was in there. So I called him from
the Willoughby Hall phone booth in the lobby of
the dormitory.

I said, "Is this Jim McMullan, the guy who does
the water color posters?" He's like, "Yeah, what do
you want?"

I didn't know what to say next. I was completely
freaked out. "Can I visit your studio?" I asked.

And he said, "Give me a call back in another
three weeks, I'm moving."

So I visited him after he had just moved to a
studio on East Thirty-Second Street in the same
building where the designer Milton Glaser had his
offices. When I arrived, he was on the phone. He sort
of motioned to a chair in the studio, and I sat down in
it, only to realize that this was the chair that he had
drawn for the cover of a *Graphis* annual, and I had
copied his illustration over and over again.

19

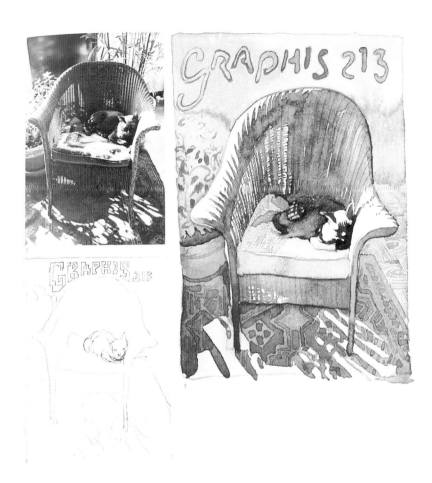

When he got off the phone, I showed him my portfolio, and again, he asked, "What are you doing here?" And I kind of lied. I said, "Oh, I want to be an illustrator." And he said, "Okay. Can you come in twice a week? I'll give you work…"

That's how I wound up working for Jim. I dropped out of Pratt, and Jim basically told me I didn't know how to draw, brought me into classes at SVA, and started to teach me. I credit him with my education.

I kept a sketchbook pretty much constantly. These are some pieces from it.

20
21

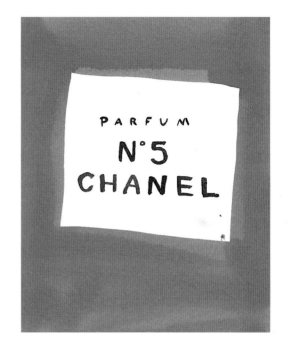

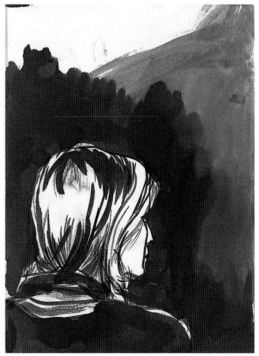

20

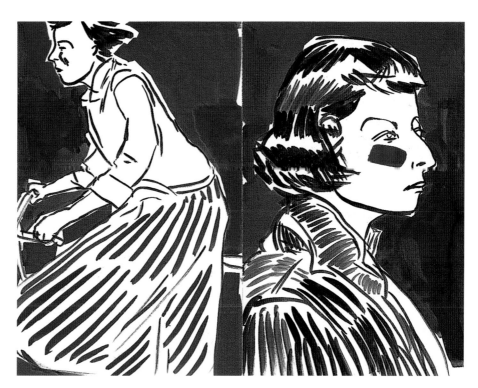

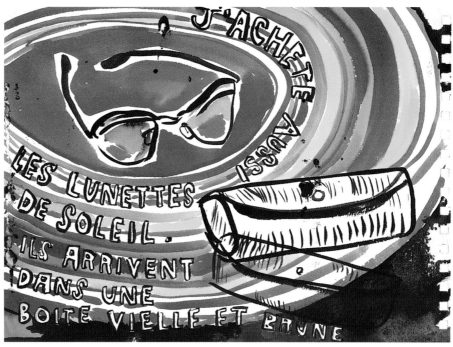

21

After Pratt, I interned at a bunch of different places. I worked in the set design department at *Saturday Night Live* and did general production assistance at the Brooklyn Academy of Music. I started to eventually get freelance assignments. My first job came from the *Globe and Mail*, a Canadian newspaper. I did ink and watercolor pieces for a section called Facts and Arguments. At the same time I began getting work from Steven Heller at the *New York Times Book Review*. One of the first drawings I did for him was of Art Buchwald's eyeglasses. I've since lost the piece.

22 This drawing of Edna St. Vincent Millay was another assignment from Steven, but it wasn't published. I did a lot of research on Millay and made about seventy-five drawings. When I do a portrait, I always look for a feature I love—it could be the shape of a mouth, a strong nose, anything. With Millay, it was her cheeks. In photographs they were always slightly hollowed and brightly flushed. They gave her an air of excitement and vitality, and, somehow, tragedy—probably because her eyes looked so sad.

23 This was a piece for Nicholas, for an Op-Ed page piece on Kennedy and Johnson. I always liked how Kennedy stood with his hands awkwardly shoved in his pockets.

22

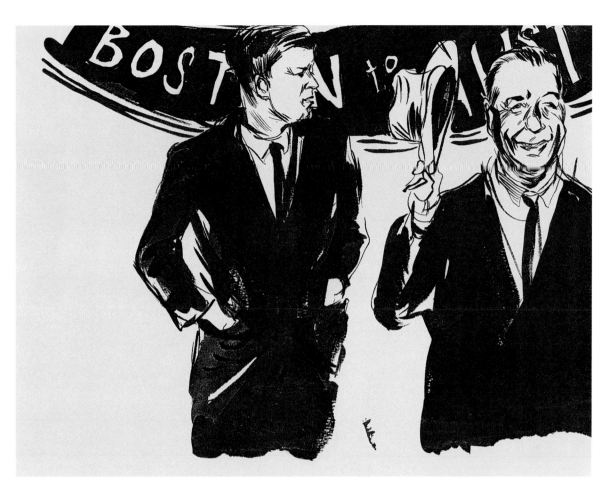

23

24 Whenever I'd read a book, I'd do fake book covers in my sketchbook. I kept on doing this until Rodrigo Corral, from Farrar, Straus and Giroux, actually gave me some real work. I love doing book covers. First I read the book, marking pages and passages where an image stands out—overtly or subtly—as a metaphor. With this metaphor in mind, I start developing a sensibility and style that I think the book could assume.

28 I did fake covers for *The Journals of Sylvia Plath*
26 and *The End Of the Affair* by Graham Greene.

25 That's a portrait of Jason, actually.

27 Rodrigo gave me a series of Hermann Hesse books to do. This is one of them.

31 *The Cyclist* was a piece I did for Paul. The book is about a bicycle-riding terrorist who is a bit of a gourmand. We actually heard back from the writer on this one. He told us that he loved it, which felt pretty good.

24

25

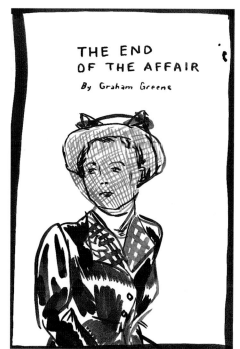

26

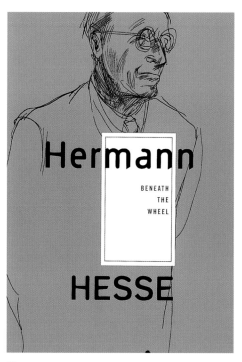

27

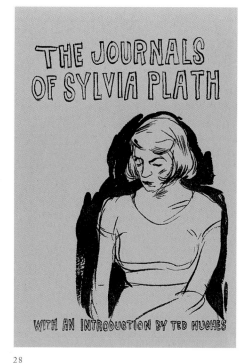

28

These are another two pieces I did for Rodrigo
30 recently: a collection of Joseph Heller pieces and a
29 cover for a novel by Chuck Palahniuk. I do a lot of
lettering for book covers. I think handwritten type can
convey so much mood, warmth, and particularity. I
32 love letterforms—lowercase g's and s's especially. Here
33 are two rejected sketches for the Palahniuk cover.

SAHRE. Leanne, how did you start getting commis-
sions? Was it because you were associated with Jim
McMullan?

SHAPTON. Well, Jim was working at a pretty high level.
He had a lot of published work. I would basically
show art directors the fake work—like the fake book
covers I'd done—and put together something that
resembled a portfolio.

SAHRE. But it does seem like there's a jump from, kind
of lying and saying that you're an illustrator, to actual-
ly be paid to draw?

SHAPTON. All you need to do is make the rounds with
your book, and eventually you'll get work. Heller's
notorious for flipping through someone's book really
quickly and just sort of saying, you know, go do more
work and come back after a while.

SAHRE. And I guess it's also just having the guts, as
someone fairly inexperienced, to call these famous
people. You know, the likes of James McMullan,
Steven Heller, Nicholas Blechman.
 [*laughter*]
I threw him in there.

SHAPTON. It happens slowly. You start off with a little
job, and then it snowballs. But it takes a while.

SAHRE. Ladies and gentlemen, Timber!
 [*Timber! enters the stage, fog machine starts up,
 rock music*]

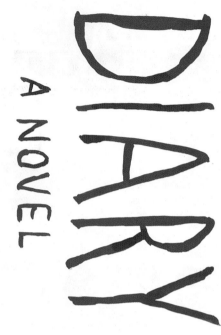

29

CATCH AS CATCH CAN

THE COLLECTED STORIES AND OTHER WRITINGS

JOSEPH HELLER

EDITED BY MATTHEW J. BRUCCOLI AND PARK BUCKER

30

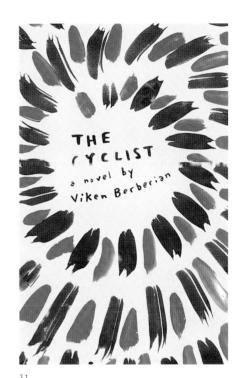

31

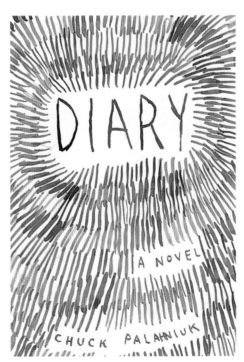

32

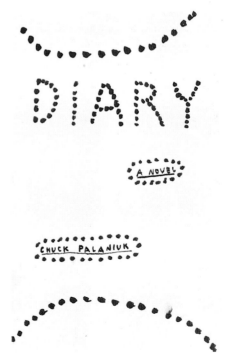

33

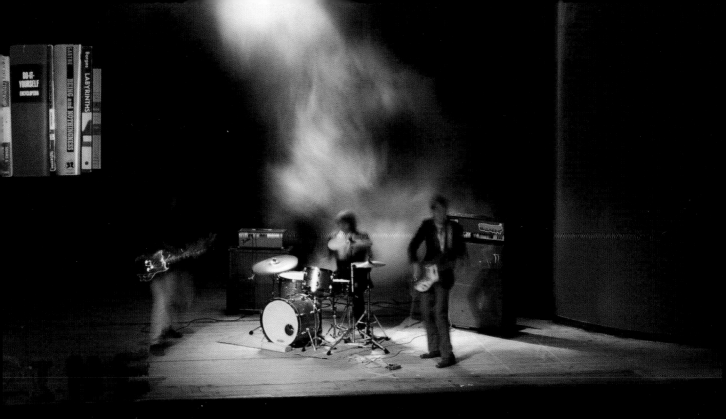

CHAPTER TWO:

Money

OR

How You Get Paid
to Continue Doing
the Things That You Love

BUCHANAN-SMITH. After graduation I had to get a
job. When I left SVA, the only place I wanted to work
at was the *New York Times*. I interviewed with Janet
Froelich at the *New York Times Magazine*, and she
graciously took me on. I worked for her for a month,
until, much to my surprise, Nicholas Blechman
resigned from the Op-Ed page, and I was asked to
take over for him.

 There were many great things about that job, but
one of them was a rubric called Op-Art, which proba-
bly many of you know by now. It is a place where
illustrators and designers are allowed to stretch out
and tell their own stories. Art-directing this rubric
was one of the most exciting aspects of the job for me.

 At this point I need to mention my partner at
our firm, Monday Morning: Dan Nadel, with whom I
collaborated on numerous projects—including this
Valentine's Day Op-Art. As Op-Art is normally on
political topics, it was nice to throw a wrench in the
works and celebrate something as frivolous and apolit-
ical as Valentine's Day. You can also see the seeds of
Speck, my first book, which I will talk about later,
being sown here.

34

iberties

REEN DOWD

Black And White

WASHINGTON
nothing like stealing a
election to put a little
y's sails.

ears in the shadows, af-
decade on the bench,
omas had a black-tie
arty last night.

ican Enterprise Insti-
rvative think tank here,
tice Thomas with an
500 guests munched on
the Washington Hilton.

e capital's new power
and Dick Cheney, Karl
n Scalia, Kenneth Starr,
and a bevy of veteran
ers. Introducing Justice
ert Bork said that while
he majority five-justice
ush v. Gore might be
e deemed the "concur-
" of three justices, in-
ice Thomas, to be on
ground."

of the Supreme Court
talked. And talked. And
Thomas said was pretty
jecting the president's
promise and harmony,
day there is much talk
ation," but there is an
sis on civility."

cannot be a governing
citizenship or leader-
d, adding that "though
hich we are engaged is
civil," one should not let

Bill's A in, W.'s team.

"cannibalized."
ong speech was so self-
self-aggrandizing that it
parison to Bill Clinton's
pardoning Marc Rich,
I that it was easy to say
courage to say yes.

was bracketed with cele-
o men who had history's
ating Senate hearings

Op-Art
ANGUS McWILTON & DANIEL NADEL

Love Found

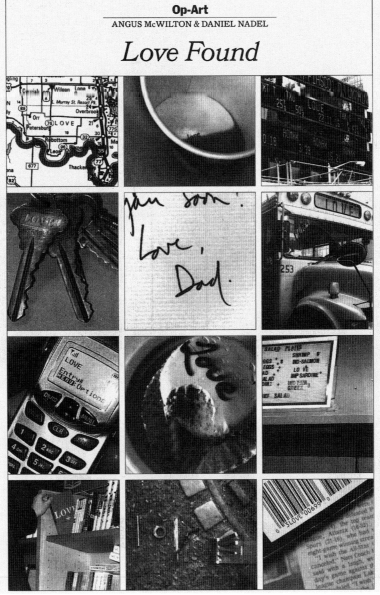

Doing t

Three weeks ago Alan
in his now-famous testi
Senate Budget Committ
cisive aid and comfort
cates of huge, irresponsi
Rumor has it that Mr.
himself was taken aback
ing frenzy unleashed by t
ny, and that he is now e
backdoor campaign to li
age. (Damage to the n
himself? Good question
ley Report, a newsletter
affairs, says that "mai
sional Democrats have
Greenspan — or his a
them that he actually f
thing like $1 trillion in t
rather than $1.6 trillion.'

But if those rumors a
Greenspan's performanc
in his first official testim
let the genie out of the b
profile in cowardice. Aga
he was offered the oppor
something that would b
runaway tax-cutting; e
evaded the question, ofter
reading from his own pr
mony. He declared once a
was speaking only for h
granting himself leeway
on subjects far afield of
Federal Reserve chairm
pressed on the crucial
whether the huge tax cu
seem inevitable are too l
it was inappropriate for
ment on particular prope

In short, Mr. Greens
the rules of the game in
allows him to intervene a
the political debate, bu
behind the veil of his offi
anyone tries to hold him
for the results of those in

Meanwhile, he dug hi
into an intellectual hole.
span's argument for ta
like this: If you believe
projections, within abou
the federal government
all its debt to the public. '
will have to accumulat
the private sector — an
lead to a politicization
cial markets. So we mu
soon to dissipate much of
ed surplus.

But does Mr. Greens
lieve his own argument?
Corzine asked the Fe
whether we ought not to
er view. As Mr. Corzine
just beyond that magic
zon the baby boomers
place immense deman

35 Dan has had a huge hand in basically everything
that you're going to see from here on out, including
another Op-Art. This one was an obituary to a
Fresh Kills landfill site, the world's largest landfill. I
was at the *Times* when it was shut down. But then, of
course, it reopened to take all the wreckage from
September 11th.

36 Another great thing about the job was working
with people like cartoonist Ron Regé, people who'd
never been published in a forum like the *Times* before.
Or Lauren Redniss, who had never had her brand of
visual journalism published on the Op-Ed page
before. It was very exciting to collaborate with her.

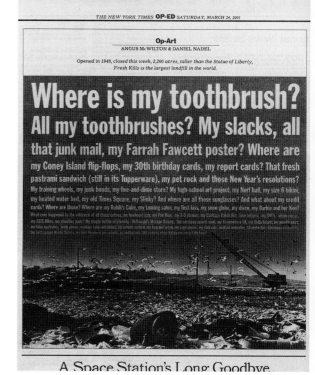

35

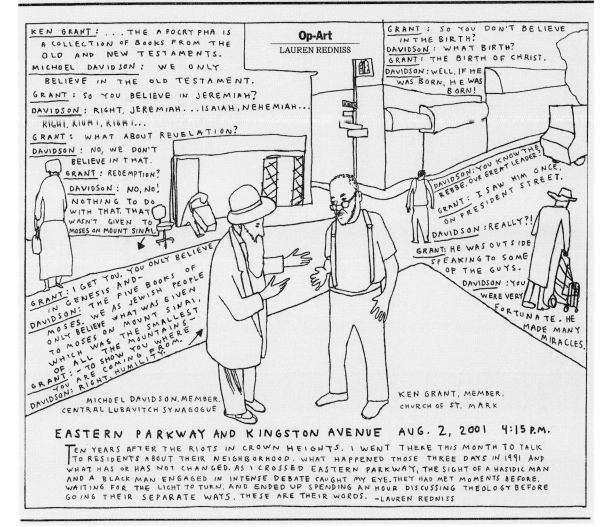

I was still at the *Times* on September 11th. It was one of the strangest things, having to walk from my apartment in the East Village up to Times Square, with the towers collapsing at my back and the Times Building in front of me. The biggest page in the history of the *New York Times* was waiting for me, and it was blank. I had no idea what I was going to do.

SAHRE. Well, people also had to have been freaking out in the Times Building all day. Right?

BUCHANAN-SMITH. Yes. As you can imagine, the *Times* was a madhouse. We were severely understaffed as they had closed down all major arteries into Manhattan, and it was rumored that our building (as well as many other locations) was a target for further attacks.

37

I went through the *Times* archives. It was like doing another obituary. The whole newspaper was covered with these colorful images of flames, blue skies, and the towers actually collapsing. I felt that the only thing I could do was to publish a picture of the World Trade Center before it collapsed—that's what most of the writers were writing about.

Essay

WILLIAM SAFIRE

New Day Of Infamy

WASHINGTON

On Sept. 11, 2001 — another date that will live in infamy — the U.S. suffered war casualties on its own soil not experienced since the bloody Battle of Antietam.

The immediate questions: What well-financed terrorist organization, under what country's secret protection, slaughtered so many Americans?

Two facts give us a key clue: (1) because no airline pilot held hostage would deliberately crash into a building, at least three killers were pilots trained to operate a large jet airliner. (2) Each of the killer-pilots was indoctrinated with fanaticism — not only to find the path to paradise in wholesale

The questions we must answer.

murder, but to embrace suicide.

That combination of relatively rare capacities shrinks the pool of suspects. Two years ago an Egyptair pilot's voice was recorded murmuring a prayer just before he plunged his Boeing 767 into the Atlantic; Egypt is still in denial, scoffing at U.S. investigators.

Who has been recruiting airline pilots and brainwashing them with dreams of eternal glory? Conversely, who has been training religious zealots to fly huge aircraft? The world of pilots is finite and we know where jet training takes place.

Why, with $30 billion a year spent on intelligence, couldn't our F.B.I., C.I.A. and N.S.A. prevent this well-coordinated, two-city attack?

Airline security at Washington-Dulles and Boston-Logan broke down, but was there no communication among conspirators that our satellites or computers could detect?

Did cardboard cutters outsmart airline security? Now our aircraft will include armed guards as passengers, and our supertech spooks will be forced back into planting human spies and suborning enemy contacts with money and blackmail.

When we get solid information about the centers and resources of the terror network, how do we retaliate?

Five years of investigation and trials and appeals, as after the first World Trade Center attack, deter nobody. Lobbing a few missiles at possible training sites, as President Clinton hastily and ineffectually did, is a demeaning pretense.

Lashing out on the basis of inadequate information is wrong, but in terror-wartime, waiting for absolute proof is dangerous. When we reasonably determine our attackers' bases and camps, we must pulverize them — minimizing but accepting the risk of collateral damage — and act overtly or covertly to destabilize terror's national hosts. The Pentagon's rebuilt fifth side should include a new Department of Pre-emption.

Did our national leadership respond well in the first hours of crisis, when nobody knew what would follow the devastation in New York and the attack in Washington?

Stopping air and rail transportation was necessary, and blocking access to national monuments and federal of-

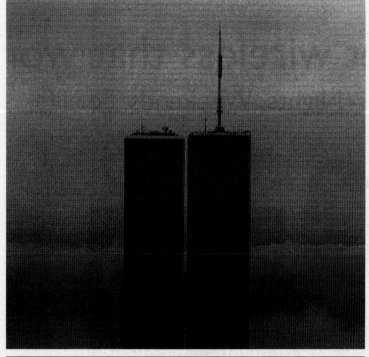

Liberties

MAUREEN DOWD

A Grave Silence

WASHINGTON

If you called yesterday afternoon to the White House switchboard, that famously efficient Washington institution, you would hear a brief recording saying to hold for an operator and then the line would go dead.

For many hours, the most eerie thing about the American capital, under attack for the first time since the British burned the White House in the War of 1812, was the stillness at the center of the city.

New York was a clamorous inferno of pain, confusion and fear, with Mayor Rudolph Giuliani on the scene in the rubble of the World Trade Center towers and on TV trying to reassure residents about schools and transportation and hospitals.

Manhattan had the noise of the grave. Washington had the silence of the grave.

Downtown you could smell the smoke and see the plume rising from a Pentagon full of carnage and fire and see the flag over the emptied White House flying at half-staff.

But until the nation's leaders reappeared on television after nightfall to speak of what President Bush called their "quiet, unyielding anger," no one understood what had happened. No one knew what might happen next. Would there be a gas attack? Would the White House blow up? Would an-

No one knew what might happen next.

other plane crash into the Capitol?

People were so hungry for clues that they gathered, as their parents did after Pearl Harbor, around radios, huddled in small groups a block from a cordoned-off White House.

A doctor, Mark Cinnamon, 54, held up a radio broadcasting Peter Jennings interviewing Gov. George Pataki, while 15 strangers leaned in to listen. "We're just sharing, with an old battery-operated radio some guy handed me," he said.

On a gorgeous blue fall day, terrorism had turned into war. The city that leads the world took on a weird neutron-bomb quality. No one even tried to pretend, as we are supposed to, that no matter what, terrorists cannot disrupt our government.

For much of the day we weren't sure where the president was. There were occasional statements floating in from the commander in chief from

various secure zones in the air or underground. We didn't know where the first lady was. The secretary of state was in the air somewhere. The Capitol had been evacuated. Congressional leaders had gone off to a bunker somewhere. The Joint Chiefs of Staff could not be immediately accounted for. The C.I.A. and F.B.I. were stunned. Most vividly at his post was Donald Rumsfeld, who helped rescue victims at the Pentagon and stayed there all day.

White House officials had fled the building five minutes after the plane crashed into the Pentagon at 9:45 a.m., streaming out with some men screaming and some women barefoot and carrying their high heels.

"That floored me," said one federal official, stranded at a bus stop. "This is supposed to be the most secure place in the world. I said, 'Why are you running? You can leave but just slow down a little.'"

Federal buildings were evacuated, coffee shops shuttered, dress shops barred. A few tourists wandered around in shorts looking confused. D.C. police carried rifles, and Secret Service agents in black Mustangs and green Luminas blocked off the streets adjacent to the White House.

The country cannot be completely protected from fanatics willing to die. And yet, it was chilling to see how

unprepared those in charge of planning seemed, after years of warnings about just such an attack. The top Congressional leaders were calling each other, unsure whether to stay or go, or where to go.

"There was some confusion; no alarm bells went off," said Mitch Daniels, the Bush budget director, about the scene in the Old Executive Office Building, adding that people had decided to go "by word of mouth."

Even the president didn't seem sure of where to go.

"He is at the very top of the United States," said Tammie Owens, a subway supervisor in a bright yellow uniform, who felt that a president, like the British royal family during the blitz, needed to reassure people with his presence. "And the White House is where he should be."

David McCullough, the historian who wrote the biographies of Harry Truman and John Adams, disagreed. Mr. McCullough happened to be in town for a Laura Bush book festival and had just volunteered to give blood at a hospital. "All presidents do what they're told on matters of security," he said. "The most important thing is that the president is alive and safe and knows what's going on. We haven't seen this level of destruction on our home ground since the Civil War. This isn't the 'Titanic' movie. It's real." □

ANTHONY LEWIS

A Different World

BOSTON

A man who worked on one of the top floors of the World Trade Center saw that he was trapped. He telephoned his wife. He said he wanted to say goodbye, he wanted her to remember that he loved her and loved their children. They are 1 and 3 years old.

A friend of his told me the story. More even than the television images, it brought home the pain, and the terror.

Thousands upon thousands of Americans will have a personal connection to a victim. Or we will imagine the feelings of the passengers on those planes, knowing they were flying to death. Schoolchildren across

America cannot fight terrorism alone; international cooperation is essential.

the country will remember the day their classes were interrupted to give them the news. We will all be marked forever by this day.

Terror is what the attackers wanted to arouse, and they succeeded. They not only visited death and destruction on symbols of American economic and political power. They showed how vulnerable the world's only superpower is: how imperfect our airport security systems, how unprotected even our military headquarters.

"Since these were acts of war," a television broadcaster said during the day, "it is important to know where our national command center is." To the contrary, it seemed irrelevant. What does a military command do about a faceless enemy that does devastating damage with no more than perhaps a dozen attackers?

If this was war, it was far from the best-remembered attack on America. Pearl Harbor was so clear. In school the next day we gathered in the auditorium and listened to President Roosevelt. "Yesterday, December 7, 1941, a date which will live in infamy . . ." No one could doubt who the enemy was or how America had to respond. Those are now the very doubts.

None of us can pretend to know exactly how to deal with this newly disclosed threat of large-scale, sophisticated terrorism. But some basics suggest themselves.

Most important, America should reach out to the rest of the world for a united stand against terrorism. Nearly all countries, whatever their politics, have a common interest in elementary security. China does. Russia does.

The world's cooperation is essential if the authors of this attack are to be found and destroyed. The United Nations must demand that all countries deny shelter to terrorists, and help to crush them. Governments that reject that demand will be targets for military action.

38

I like this piece here. Occasionally—usually out of emergency—I would have to step in and do my own illustration, particularly when someone had dropped the ball at the last minute. Every day of the year, there's got to be something on that Op-Ed page, no matter what. But this one, about Katharine Graham, former publisher of the *Washington Post*, I just had to do myself. I felt that doing this piece myself, as opposed to having an outside freelancer work on it, made it more of a nod from one newspaper to another.

SAHRE. How did you handle the pressure? Sure, SVA was a lot of pressure too. But now you're at the *New York Times*. I know from firsthand experience that it's a ridiculously stressful job. And by the way, who is Angus McWilton?

BUCHANAN-SMITH. Oh, Angus is my alter ego. See, I'm from a farm in Canada. Angus was an Angus bull, a big, black bull on our farm. We called him Angus McWilton. He used to scare the hell out of me.

SAHRE. So you took his identity as a pseudonym...why?

BUCHANAN-SMITH. Well, *Times* editors weren't allowed to take credit for pieces published on the Op-Ed page. They may commission writing but the content of the page is meant to be impartial; thus it would be perceived as slightly unethical if staff members were to be seen manufacturing the opinion, which they basically did anyway. This was one reason for my pseudonym. Another reason was that I often had to do illustrations at the last minute, which tended to be "below-standards," and I didn't want to attach my own name to them.

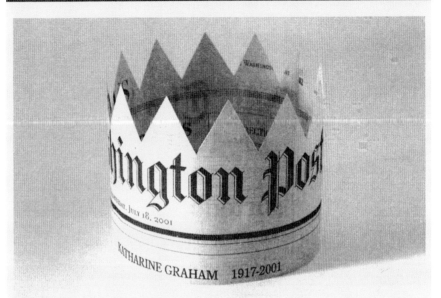

Angus McWilton

The Reign of a Great Publisher

By Ward Just

WEST TISBURY, Mass. The term "publisher," as used in the news business, is unique. Its equivalents elsewhere, chief executive officer or chairman, do not bear the same weight or convey the same authority. A publisher has the responsibility of a skipper on the bridge of a vessel, mindful always of the rigging, the weather, the course, the morale below decks and, not least, the safe delivery of the cargo, the news, good and bad. The news business has its own amendment of the Constitution of the United States, which gives the cargo a special value and the skipper a special duty.

All publishers pay attention to the black ink at the end of the fiscal year, or they will not publish for long. But the black ink is a function of the reliability of the words on the page, not the reverse. Anyone can learn the ins and outs of a balance sheet, but to

great achievements — the publishing of the Pentagon Papers (with The New York Times), Watergate, the hiring of Ben Bradlee and all the rest — the one thing she seemed to take the most pride in was the Pulitzer Prize she received for her memoir, "Personal History."

Kay Graham seemed to accept Washington as her personal responsi-

Katharine Graham's strength of character.

bility, a sort of civic duty. For many years, her house in Georgetown was the closest thing to a salon for people who made the capital go. This was the old Washington, a place as unbuttoned and conversational as a Left Bank cafe. Republicans, Democrats, wits and bores, all found a way to her

you had been around as long as she had been, there were plenty of them.

She seemed to take special pleasure in her house on Martha's Vineyard, and in the last few years her dinners there were especially memorable. Business people like Warren Buffett and Bill Gates might show up, but mostly the guests of honor were Formers — former secretaries of state (one evening a few years ago, four of them sat around her table, the talk less lively than one might expect, with the sound of rattling skeletons in hidden closets), of defense and treasury; former directors of central intelligence; former ambassadors — many of them witnesses to the birth of the modern world.

Kay sometimes led the conversation but more often seemed content to listen, now and then contributing a thought or anecdote. She seemed to be less hostess than cosmic secretary-of-everything. And at the end of the evening, always with a glass of soda water, she would replay things, the contributions of this supremo and that — and didn't you think so-and-so was

FULFORD. My road trips couldn't continue without
money, so I had to get work. I wanted to earn my
living taking the kind of pictures I like to take, so
I started making a lot of self-promo pieces in my
darkroom. Homemade, with photo paper and
lamination.

39 This was one of the first ones. I sent it out to
friends and designers just before that big bike trip. It's
a map of the Mississippi River, with some contact
information and some pictures of me on a motorcycle.

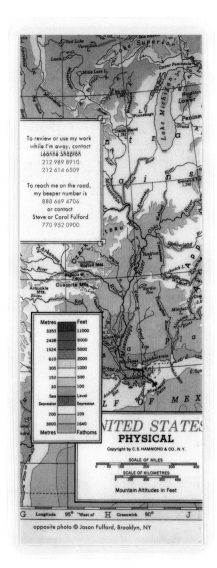

To review or use my work
while I'm away, contact
Leanne Shapton
212 989 8910
212 614 6509

To reach me on the road,
my beeper number is
888 669 4706
or contact
Steve or Carol Fulford
770 952 0900

Metres	Feet
3353	11000
2438	8000
1524	5000
610	2000
305	1000
152	500
30	100
Sea	Level
Depression	Depression
200	109
3000	1640
Metres	Fathoms

UNITED STATES
PHYSICAL
Copyright by C.S. HAMMOND & CO., N.Y.

SCALE OF MILES
SCALE OF KILOMETRES

Mountain Altitudes in Feet

opposite photo © Jason Fulford, Brooklyn, NY

For a while, I was faking my way into getting
42 press passes for sports events. I went to the Kentucky
Derby, a bodybuilding competition, baseball games,
and the Golden Gloves.

40 This was a piece I made after shooting at a
WWF match. For some reason these quiet, banal
American landscapes seemed to fit well with the crazy
wrestling scenes. I guess you can imagine the fans
living in places like these, watching the matches on TV.

41 This is a Christmas card—a Christmas portrait
of you with your favorite gift. That's my friend Ted
with his surfboard.

[*laughs*]

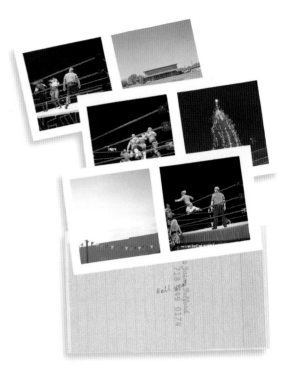

40

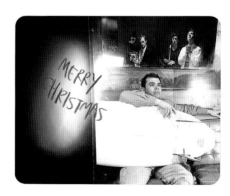

41

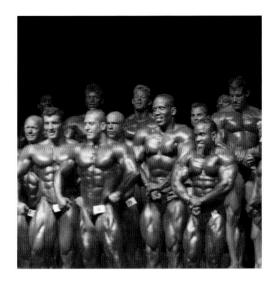

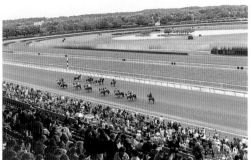

I'd like to talk a little bit about how to get paid for taking pictures. It's important to show art directors and photo editors only the kinds of pictures you *like* taking. Once they get a feel for your sensibilities, they'll call you when an appropriate job comes up. I started looking for jobs by seeking out graphic designers I respected and showing them my personal work.

43 My first published photo was picked by Archie Ferguson at Knopf for a Simon & Schuster novel called *The Good Brother* by Chris Offutt. I had taken the picture on a bird-hunting trip with my dad and his buddies.

44 Paul designed this cover of Bertrand Russell's book *The History of Western Philosophy* for Touchstone, using two pictures I'd taken somewhere out in the Midwest.

SAHRE. Well, it's interesting. I designed this after seeing a page in your book *Sunbird* that had these two images side by side with some white space in between. It's kind of funny how collaboration works. In some instances, the photographer is more of a designer than the art director.

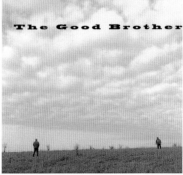

43

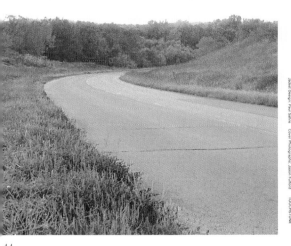

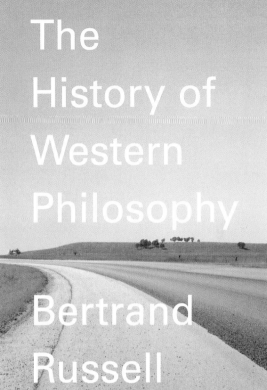

The History of Western Philosophy

Bertrand Russell

ISBN 0-671-20158-1

THE HISTORY OF WESTERN PHILOSOPHY—BERTRAND RUSSELL Philosophy—$24

Since its first publication in 1945, Lord Russell's *A History of Western Philosophy* has been universally acclaimed as the outstanding one-volume work on the subject—unparalleled in its comprehensiveness, its clarity, its erudition, its grace and wit. In seventy-six chapters he traces philosophy from the rise of Greek civilization to the emergence of logical analysis in the twentieth century. Among the philosophers considered are: Pythagoras, Heraclitus, Protagoras, Socrates, Plato, Aristotle, Augustine, Aquinas, Machiavelli, Erasmus, More, Bacon, Hobbes, Descartes, Spinoza, Leibniz, Locke, Berkeley, Hume, Rousseau, Kant, Hegel, Schopenhauer, Nietzsche, Marx, and lastly the philosophers with whom Lord Russell himself is most closely associated—Cantor, Frege, and Whitehead, co-author with Russell of the monumental *Principia Mathematica*.

Jacket Design: Paul Sahre Cover Photographs: Jason Fulford

TOUCHSTONE

45 FULFORD. This was another job where I used my archive. Stacey Clarkson from *Harper's* magazine called me up with a fiction piece. She said she'd like to run a grid of nine images with it. So I read the story, went through the archive, and picked about sixty that fit—pictures that related to the mood and the location of the story without giving away all the narrative. Over the course of a week, we narrowed it down together.

46 Rodrigo Corral did this cover. He wanted a wallpaper pattern with images of texture. So I gave him about 150 images, and he put this together.

These two covers used a mixture of commissioned photographs and shots from the archive. The author, Don DeLillo, had a specific request for the

48 cover of his book *White Noise*. The novel is about an American family and a toxic cloud that looms over their town. DeLillo wanted the cover to convey an American small-town feeling with a subtle sense of menace. *White Noise* is one of my favorite books, so I gave the art director, Paul Buckley, at Penguin about one hundred images to choose from. The bottom image here is actually from Budapest, and the one on top is from the Gulf of Mexico!

47 For the cover of *End Zone*, a book about west Texas, college football, and nuclear war, we used a picture of a flat landscape from the archive. Then I shot a football in Brooklyn, falling like a bomb.

SAHRE. Jason, real quick, a question along the lines of what you were just saying there. As I mentioned before, you do a lot of traveling and shooting. Yet, even when you shoot in Hungary, Mexico, or China, your photographs still feel American. Can you explain this?

45

WHAT ARE YOU LIKE?
Anne Enright

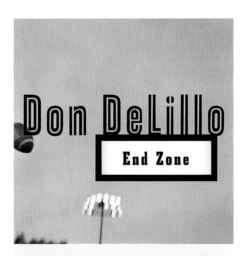

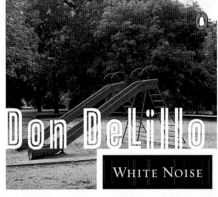

FULFORD. I think that we're trained, based on where we grow up, to look at the world a certain way. It's unavoidable and unconscious. So the things that I end up seeing in other countries are things that I relate to somehow. I just got back from Seoul, for instance, where I felt strangely at home—despite the cultural differences—because Seoulites are such consumers!

For these two books, I was commissioned to take new pictures. The art director at Scribner's, John Fulbrook, had a really specific idea of what he wanted for the cover of Don DeLillo's novel *Cosmopolis*. The book is about a rich man's crazy afternoon crossing midtown Manhattan in a white limo. John actually drew a picture of what he had in mind before I went out to shoot. I rented a white limo and drove around with a bunch of my friends all day. We would stop every once in a while, and I'd jump out and take a picture.

While I was living in China last year, Archie Ferguson e-mailed me about the book *The Crazed* by Ha Jin. He said he needed a picture of a *teng-yee* standing in a hospital room. First of all, I had to figure out that a *teng-yee* is a type of old Chinese wicker chair. I went to a flea market in Beijing and found what I thought was one. I asked the man "*Zhi shi teng-yee ma? Shi lao ma?*" And he goes "*Dui, dui!*" I think it was actually a dirty IKEA chair in the shape of an old *teng-yee*. But it worked. You can't tell. Then I snuck into the Beijing Teacher's College, which felt like an old hospital, to shoot the chair.

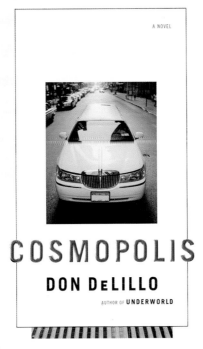

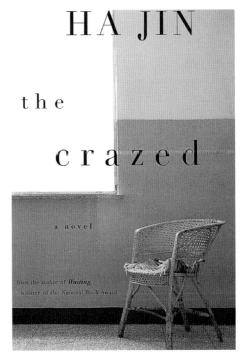

51
53

Leanne would hire me occasionally for *Saturday Night*. Oh, this job was fun. The assignment was to take a three-week road trip across Canada documenting tourist spots. I rented a car and drove coast to coast, FedExing film to Toronto every few days. The magazine wanted an outsider's perspective—a non-Canadian traveling around Canada. At the end of the trip, Leanne and I edited the story. It ended up as eight pages of grids and single images.

52
54

This article, "How Far Should We Go?," for the *New York Times Magazine*, involved lots of different collaborations. The article is about Homeland Security and how it could end up affecting daily life in this country. We started off with a general idea of what kinds of images the editors wanted in the piece. Photo editor Kira Pollack and I selected images from my archive and then compiled a list of pictures that needed to be shot. We slowly refined the selection as the designers began laying it out. The process of editing the pictures took about three weeks. We picked normal, everyday scenes of American life, and then Nicholas Blechman drew scary Homeland military imagery on top.

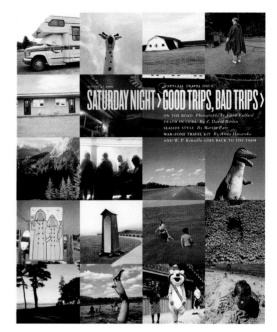

51

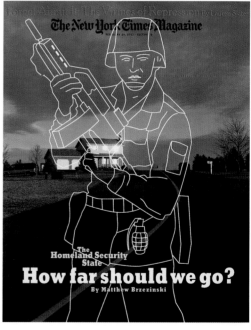

52

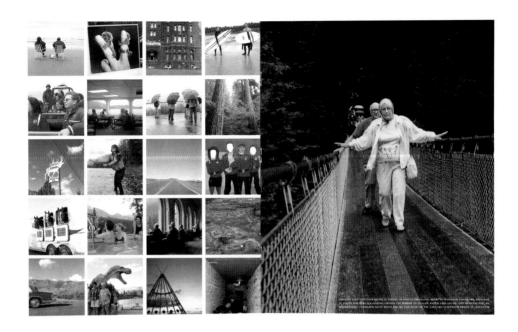

Fortress America

Creating genuine homeland security would cost trillions
of dollars and completely change the way we go about our lives.
Is this where you want to live?

By Matthew Brzezinski

Photographs by Jason Fulford Illustrations by Nicholas Blechman

In the last several weeks, as preparations for the war against Iraq have heated up, it has begun to sink in that this will be a different conflict from what we have seen before — that there may, in fact, be two fronts, one far away on the ground in the Middle East, the other right here at home. For the first time in history, it seems plausible that an enemy might mount a sustained attack on the United States, using weapons of terrorism. The term "soft targets," which refers to everyday places like offices, shopping malls, restaurants and hotels, is now casually dropped into conversation, the way military planners talk about "collateral damage."

Earlier this month, the federal government raised the official terrorism alert level and advised Americans to prepare a "disaster supply kit," including duct tape to seal windows against airborne toxins. Members of Congress organized news conferences to demand that passenger jets be outfitted with missile-avoidance systems. In major public areas of cities, the police presence has been especially conspicuous, with weapons ostentatiously displayed. Whatever the details, the message was the same: war is on the way here.

The impossible questions begin with where, what and how, and end with what to do about it. Sgt. George McClaskey, a Baltimore cop, spends his days thinking about the answers, and one cold day recently, he took me out in an old police launch to survey Baltimore harbor. He showed me some of the new security measures, like the barriers at the approach to the harbor, which rose out of the water like stakes in a moat. Cables were suspended between these reinforced pylons, de-

signed to slice into approaching high-speed craft and decapitate would-be suicide bombers before they reached their mark. It looked fairly daunting.

Then McClaskey maneuvered the boat toward an unprotected stretch of Baltimore's Inner Harbor. With the temperature dipping into the teens, the place was empty. But when the weather is warm, up to a quarter of a million people congregate on these piers and brightly painted promenades every weekend.

"If I wanted to create a big bang," McClaskey said, adopting the mind-set of a suicide bomber, "I'd pack a small boat with explosives and crash it right there." He pointed to a promenade. "It'd be a catastrophe," he declared. "It would take 48 hours just for the tide to flush out the bodies from under the boardwalk."

The port is lined with large oil terminals, storage tanks and petrochemical facilities, incendiaries in need only of a lighted fuse. Even the Domino sugar refinery, with its sticky-sweet flammable dust, poses a threat. "Most people don't think about it," McClaskey said, "but that's a giant bomb."

The list of vulnerabilities is perilously long in Baltimore, as it is just about everywhere in the United States. And every one of those potential targets can set in motion an ever-broadening ripple effect. Should terrorists manage to blow up an oil terminal in Baltimore, for instance, the nearby ventilation systems for the I-95 tunnel would have to be shut. Shut down the tunnel, and the Interstate highway must be closed. Close down a section of I-95, and traffic along the

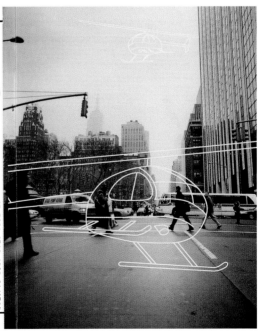

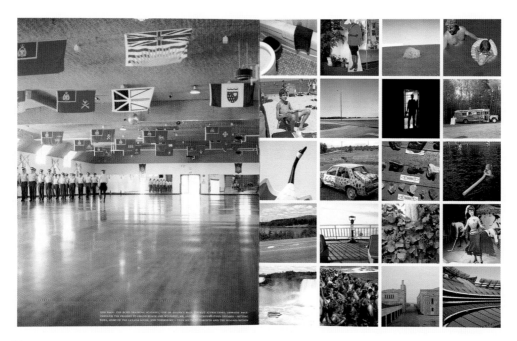

53

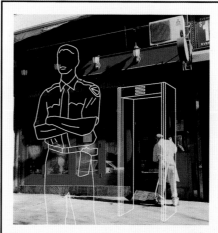

54

a rainy weekday morning before the food courts and multiplex theater had opened.

The future shopping experience will start at the parking-lot entrance. Booths manned by guards will control access to and from lots to prevent terrorists from emulating the Washington sniper and using parking lots as shooting galleries. Cars entering underground garages will have their trunks searched for explosives, as is the practice in Manila. It has also become common outside New York City hotels. This will guard against car or truck bombs of the type that blew up beneath the World Trade Center in 1993.

No one will be able to drive closer than a hundred yards to mall entrances. Concrete Jersey barriers will stop anyone from crashing a vehicle into the buildings — a favored terrorist tactic for American targets overseas — or into the crowds of customers lining up. Screening will follow the Israeli model: metal barricades will funnel shoppers through checkpoints at all doors. They will be frisked, and both they and their bags will be searched and run through metal detectors. Security would be tightest in winter, says a former senior F.B.I. agent, because AK-47's and grenade belts are easily concealed beneath heavy coats.

What won't be concealed, of course, are the weapons carried by the police at the mall. Major shopping areas will not be patrolled by the docile, paid-by-the-hour guards to whom we're accustomed, but — like airports and New York City tourist attractions — by uniformed cops and soldiers with rifles.

What will it be like to encounter such firearms on a regular basis? I lived for years in Moscow, and after a short time, I rarely noticed the guns. In fact, I tended to feel more uncomfortable when armed guards were not around; Israelis traveling in the United States occasionally say the same thing. But despite the powerful presence of guns in popular culture, few Americans have had much contact with the kind of heavy weapons that are now becoming a common sight on city streets. Such prominent displays are meant to convey the notion that the government is doing something to ward off terrorists, but they can have the reverse effect too, of constantly reminding us of imminent danger.

Even more mundane procedures might have the same effect — for example, being asked to produce a national identification card every time you go into a store, much the same way clubgoers have to prove they are of age. The idea of a national identity card, once widely viewed as un-American, is gaining ground in Washington, where some are advocating

'Security at the main buildings might stop environmental protesters or the lone crazy, but it doesn't help in the case of a truck loaded with explosives. . . . Why give yourself so little room?'

standardizing driver's licenses throughout the country as a first step in that direction. Though perhaps reminiscent of Big Brother, these cards are not uncommon in the rest of the world, even in Western Europe. In Singapore, the police frequently ask people to produce their papers; it becomes so routine that people cease being bothered by it. How long would it take Americans to become similarly inured?

The new ID's, which are advocated by computer industry leaders like Larry Ellison of Oracle, could resemble the digital smart cards that Chinese authorities plan to introduce in Hong Kong by the end of the year. These contain computer chips with room to store biographical, financial and medical histories, and tamper-proof algorithms of the cardholder's thumbprint that can be verified by handheld optical readers. Based on the $194 million Hong Kong has budgeted for smart cards for its 6.8 million residents, a similar program in the U.S. could run as high as $16 billion.

Among other things, a national identity card program would make it much harder for people without proper ID to move around and therefore much easier for police and domestic-intelligence agents to track them down. And once found, such people might discover they don't quite have the rights they thought they had. Even now, for instance, U.S. citizens can be declared "enemy combatants" and be detained without counsel. Within a few years, America's counterterrorist agencies could have the kind of sweeping powers of arrest and interrogation that have developed in places like Israel, the Philippines and even France, where the constant threat of terrorism enabled governments to do virtually whatever it takes to prevent terrorism. "As long as you worry too much about making false arrests and don't start taking greater risks," says Offer Einav, a 15-year Shin Bet veteran who now runs a security consulting firm, "you are never going to beat terrorism."

In years past, the U.S. has had to rely on other governments to take these risks. For example, the mastermind of the 1993 W.T.C. bombing, Ramzi Yousef, was caught only after Philippine investigators used what official intelligence documents delicately refer to as "tactical interrogation" to elicit a confession from an accomplice arrested in Manila. In U.S. court testimony, the accomplice, Abdul Hakim Murad, later testified that he was beaten to within an inch of his life.

In Israel, it is touted that 90 percent of suicide bombers are caught before they get near their targets, a record achieved partly because the Shin Bet can do almost anything it deems necessary to save lives. "They do things we would not be comfortable with in this country," says former Assistant F.B.I. Director Steve Pomerantz, who, along with a growing number of U.S. officials, has traveled to Israel recently for antiterror training seminars.

But the U.S. is moving in the Israeli direction. The U.S.A. Patriot Act, rushed into law six weeks after 9/11, has given government agencies wide latitude to invoke the Foreign Intelligence Surveillance Act and get around judicial restraints on search, seizure and surveillance of American citizens. FISA, originally intended to hunt international spies, permits the authorities to wiretap virtually at will and break into people's homes to plant bugs or copy documents. Last year, surveillance requests by the federal government under FISA outnumbered for the first time in U.S. history all of those under domestic law.

New legislative proposals by the Justice Department now seek to take the Patriot Act's antiterror powers several steps further, including the right to strip terror suspects of their U.S. citizenship. Under the new bill — titled the Domestic Security Enhancement Act of 2003 — the government would not be required to disclose the identity of anyone detained in connection with a terror investigation, and the names of those arrested, be they Americans or foreign nationals, would be exempt from the Freedom of Information Act, according to the Center for Public Integrity, a rights group in Washington, which has obtained a draft of the bill. An American citizen suspected of being part of a terrorist conspiracy could be held by investigators without anyone being notified. He could simply disappear.

The Face-to-Face Interrogation on Your Vacation

Some aspects of life would, in superficial ways, seem easier, depending on who you are and what sort of specialized ID you carry. Boarding an international flight, for example, might not require a passport for frequent fliers. At Schiphol Airport in Amsterdam, "trusted" travelers — those who have submitted to background checks — are issued a smart card encoded with the pattern of their iris. When they want to pass through security, a scanner checks their eyes and verifies their identities, and they are off. The whole process takes 20 seconds, according to Dutch officials. At Ben-Gurion in Israel, the same basic function is carried out by electronic palm readers.

"We start building dossiers the moment someone buys a ticket," says

Einav, the Shin Bet veteran who also once served as head of El Al security. "We have quite a bit of information on our frequent fliers. So we know they are not a security risk."

The technology frees up security personnel to focus their efforts on everybody else, who, on my recent trip to Jerusalem, included me. As a holder of a Canadian passport (a favorite of forgers) that has visa stamps from a number of high-risk countries ending in "stan," I was subjected to a 40-minute interrogation. My clothes and belongings were swabbed for explosives residue. Taken to a separate room, I was questioned about every detail of my stay in Israel, often twice to make certain my story stayed consistent. Whom did you meet? Where did you meet? What was the address? Do you have the business cards of the people you met? Can we see them? What did you discuss? Can we see your notes? Do you have any maps with you? Did you take any photographs while you were in Israel? Are you sure? Did you rent a car? Where did you drive to? Do you have a copy of your hotel bill? Why do you have a visa to Pakistan? Why do you live in Washington? Can we see your D.C. driver's license? Where did you live before Washington? Why did you live in Moscow? Are you always this nervous?

A Russian speaker was produced to verify that I spoke the language. By the time I was finally cleared, I almost missed my flight. "Sorry for the delay," apologized the young security officer. "Don't take it personally."

El Al is a tiny airline that has a fleet of just 30 planes and flies to a small handful of destinations. It is also heavily *Continued on Page 54*

SAHRE. Leanne, after your earlier work as an illustrator, which we saw before, you've taken a radical turn. Basically, you've changed chairs, sitting down in the art director's chair instead of the illustrator's, and getting involved in the editorial side as well.

SHAPTON. Yes, that's right. In 1997 I was interning at *Harper's* magazine under their art director, Angela Reichers. My job was to suggest illustrators, do research, and to collect the art that the editors wanted to see for use in the Readings section. The amount of art I saw was really exciting and inspiring.

Around that time, I had gotten it in my head that Canada should have a freestanding book review in the national newspaper. There was only one at the time, called the *Globe and Mail. Harper's* magazine publisher, Rick MacArthur, was a columnist for the *Globe and Mail* then. I told him about my idea, and he promised to bring it up next time he was there. And indeed, he did ask them why there was no book review, to which they replied that they didn't really want one. But when he came back, he told me that Conrad Black was thinking of starting up a new national newspaper in Canada.

So I called up Ken Whyte, who had been appointed as the editor in chief of the new paper. It was another one of those scary conversations during which he said, "What do you want, and who the hell are you?"

[*laughs*]

55

Ken Whyte - 368 - 5378

Karina Onsted - 533-4360
Jason Logan - 532-6918
My fax: 535-5920.

But I got a meeting that afternoon somehow. He pulled out a prototype of the newspaper, which was called, at that point, the *Canadian*—later to be called the *National Post*. He took me through the paper and asked me what I thought of it. When we got to the central spread of the Arts and Life section, I went on and on about the virtues of visual journalism, and how successful a concept like Op-Art was at the *New York Times*, where Nicholas Blechman was then working. The next day he called me and offered me that section, which would be called Avenue.

I was in over my head, but I said yes. I was totally terrified. I had to edit, design, and art direct—and every single day the page closed at four in the afternoon. It was completely insane.

SAHRE. More stress.

SHAPTON. Yes, but I loved it. I came to every morning meeting with an idea for the section. At the meeting, the editor in chief either gave his approval, or suggested a different angle. I ended up doing various types of stories in the paper. The editors of the Arts and Life section often suggested a story, which was helpful, but I developed ideas from other sections of the paper as well—sports, foreign, business—as long as the stories lent themselves to being told visually.

56 Many stories were directly responding to the news, like this one, which came out the day after the Columbine tragedy. I pulled a picture of a Tec-9 weapon off of the Internet, because that's where the kids had bought their guns. And it actually did say "weapon of choice among violent offenders" on the site. We showed it at actual size.

AVENUE

Arts, Culture & Society

THE PARTY'S OVER, SAYS MR. BORING

THE TEC-9 SEMI-AUTOMATIC PISTOL: "AS TOUGH AS YOUR TOUGHEST CUSTOMER"

GEISHA ARTS ON THE CURRICULUM

"WEAPON OF CHOICE AMONG VIOLENT OFFENDERS"

(actual size)

TARGETING A FIREARMS MANUFACTURER

57 When Harry Potter got really big, I did a chronology of the boy hero that ranged from the Tom Sawyer/Huck Finn kind of a boy hero to Charlie Bucket from *Charlie and the Chocolate Factory*, and all the way up to Harry Potter.

58 Around the time of the impeachment business, I would scan the photo wires every day and look for patterns. One day Ken and I realized that all the characters in this drama were being photographed through car windows. The only one who had his window rolled down was Kenneth Starr.

59 This was another fun one. I sent a photographer named Chris Wahl down to Washington to follow ABC White House correspondent Sam Donaldson on the last day of the impeachment trials.

60 Another way I'd use the page was as prime real estate—as a place where I could print art big. This was a story for Remembrance Day, which I guess is called Veterans Day in the States. I asked everyone in the newsroom to bring in pictures of their family who had served in the war, taken when they came home on leave.

57

58

59

60

61 Another use for the page was to bring in contributors. This is Seth, a comic-book artist whose work I had loved for years. I gave him the page every month to do a feature we called the "National Funnies," which was whatever the hell he wanted.

[*laughs*]

62 Dave Eggers, editor and designer of the literary magazine *McSweeney's*, did a piece on Canadian Thanksgiving. I'd seen one of the early issues of *McSweeney's* and loved its distinct deliberateness. So I contacted Dave, and he submitted a play rendered in floor plans.

63 I gave an illustrator from Paris, called Emmanuel Pierre, a list of the meaning of flowers, and he illustrated it for Valentine's Day.

64 Here I got a bunch of people to do bookplates for a book festival. They included Mark Alan Stamaty, Jason Logan, Claude Martel, R. O. Blechman, Alain Pilon, Seymour Chwast, Manis Bishofs, and Fiona Smyth among others.

61

62

63

64

65 This is a drawing I did to convince Ken that there should be a poster every month, which could just be big and pretty. I would ask an illustrator to do a poster that showed the name of the month and the name of the section, and which included newspapers in some way. People solved this problem differently each month. Some had a character swatting a fly with the paper, some would be burning it for warmth, and so on.

SAHRE. Overall, you were probably working with people whose work you loved. Right?

SHAPTON. Yup, that was the point.

SAHRE. And also finding ways of fitting people in that wouldn't normally be appropriate in a newspaper?
66 Such as this French illustrator Blex Bolex, who basically draws these gigantic penises on all of his male characters. You got him not to do that here, which is commendable.

SHAPTON. He sent me five sketches. Four had huge penises.

SAHRE. I'm talking going-across-the-spread penises—held up with stilts?

SHAPTON. Yeah.

[*laughs*]

It was fantastic.

68 This poster is by is Brian Cronin, an Irish artist and illustrator. Working with him was very rewarding; he's a very smart conceptualist with an original and beautifully sensitive style. I could always rely on getting something from him that would look great in newsprint.

69 Paul Davis, from England (not to be confused with the American Paul Davis), did this piece on his first visit to Canada. He was very impressed by the snow.

[*laughs*]

65

66

68

69

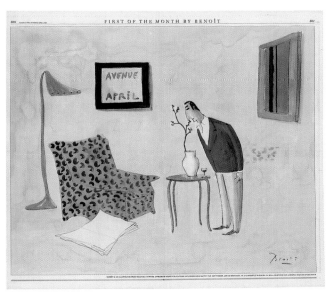

70

71

70 This poster was done by Benoît Van Innis, an illustrator from Belgium. I'd loved his covers for the *New Yorker* for years. He is one of my all-time favorites. He's got a terrific sense of humor—subtle and absurd—and his lines are great. Something about his work reminds me of Erik Satie.

67 French-Canadian Alan Pilon had the ballplayer using the paper for batting practice.

71 Avenue December was one I did myself because one fell through. That's Nicholas!

72 And I got to hire Jim McMullan, which was fun.

SAHRE. Was he a pain to work with?

SHAPTON. Yeah. Totally!

[*laughs*].

No, not really. I'm kidding.

Art directing was a lot of fun for me. I was never formally trained as a designer, so it's a very instinctual thing. I love reading and working closely with editors. Doing the Avenue pages was difficult, as it was my first real job. I made hideous mistakes at first but eventually I got the hang of it. It was the most custom-fit job I've had.

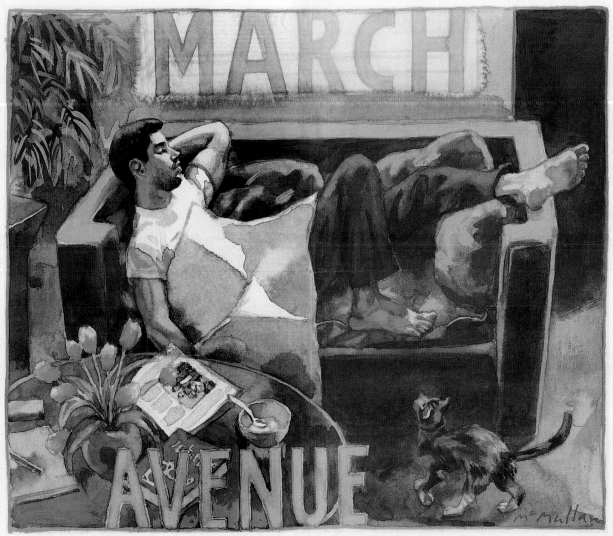

JAMES McMULLAN IS AN ILLUSTRATOR WHO GREW UP IN CHINA, INDIA AND CANADA. HIS THEATRE POSTERS APPEAR REGULARLY AT LINCOLN CENTRE IN NEW YORK CITY.

Eventually, after a year, I got exhausted and burnt out. I was hired to redesign *Saturday Night*, which was a monthly magazine—Canada's oldest magazine. In this new position, I hired Paul to help me with the redesign, which entailed about a month of intense work. It was really fast. We had to turn a monthly magazine into a weekly that would be folded into the weekend paper. I felt that *Saturday Night* was visually incoherent in its earlier version but its content and spirit was very strong. We changed almost everything, from the size to the paper stock.

73 Here are some covers. This photograph by Christopher Griffith was on the cover of the second issue.

74 This was a cover about dolphins not being as nice as we think. Sometimes they bite and hump the people who pay to swim with them.

[laughs]

75 For this piece about the popularity of Jewish culture in Berlin we cast the most Aryan-looking models we could find and made T-shirts that said: "Some of my best friends are Jewish," and "I'm with Moishe."

76 Artist David Shrigley's cover was one of my favorites.

77 Nicholas Blechman used a drawing from his sketchbook for the cover of the *Love and Marriage Issue*.

78 Barbara Kruger worked on this cover with me.

73

74

75

76

77

78

My favorite parts of working on *Saturday Night* were choosing covers and commissioning unlikely artists. I loved seeing the magazine's personality get stronger and see the whole staff feel it too.

When *Saturday Night* folded, Ken asked me to design a broadsheet weekend section called *Saturday Post*. I worked on this with a designer named Lucy Lacava who had done the original design of the news-
81 paper. Here are two covers, one for a regular issue
82 (McMullan again), the other for a fashion issue.

I think that you get a much more emotional sense of an object or article of clothing that is drawn, instead of photographed. I have a Hermès catalog from 2000 that illustrator Phillipe Weisbecker created, which I admire very much. I tried to have as much fun as I could with the style section of the magazine.

79 Filip Pagowski illustrated bathing suits.

80 Photographer Paul Graham shot teenagers wear-
ing expensive sunglasses.

83 Weisbecker did a big story on mesh.

SAHRE. The most interesting thing for me, in this redesign, was that you were really acting as an editor.

SHAPTON. I think all good art directors should be able to both art-direct and edit to some extent. All of the best editors, in my opinion, know and appreciate the strengths of good art direction.

SAHRE. How did you manage to be in that position?

SHAPTON. By having ideas. You just sort of say to yourself, "This should happen." And then you make it happen.

SAHRE. Ladies and gentlemen, Timber!

[*Timber! enters the stage, rock music*]

79

80

81

82

83

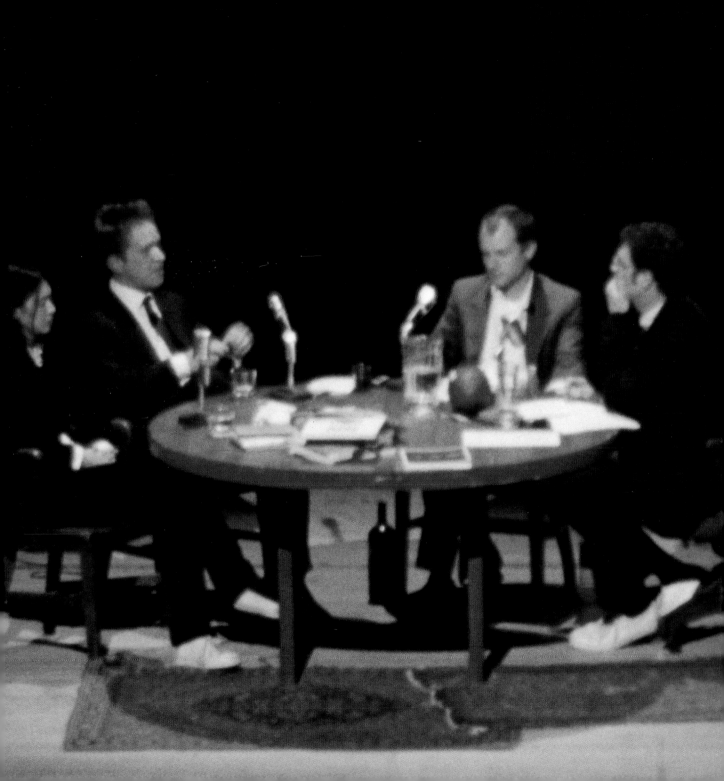

CHAPTER THREE:

Books

AND

Publishing

BUCHANAN-SMITH. My first book, *Speck*, developed out of my graduate thesis and involved a lot of the projects that I had been working on while at SVA. The book starts with a photograph of a red balloon that's being released into a Brooklyn sky. In fact, we actually did release a helium balloon with a tag attached to it saying, "Whoever finds this, please contact us." And sure enough, two little girls from Atlanta found the balloon and wrote us a letter. That's what you discover in the book's last chapter.

FULFORD. I've tried that so many times, and no one's ever written back!

[*laughs*]

BUCHANAN-SMITH. *Speck*, as the subtitle suggests, is "A Curious Collection of Uncommon Things." The subjects were primarily chosen for conceptual reasons—I wasn't at all interested in photographic or illustrative fashions, so it was a great bonus if they looked good as well. It was very important to me that the images appear to have some love, or, at the very least, obsession, invested in them.

For example, I sent a photographer to document the backs of famous paintings.

Someone documented very close-up shots of used women's lipsticks, which became these really beautiful sculptural elements. It is fascinating to see how many different shapes a used lipstick can take.

A friend of mine did a great interview with a shoe shiner, the last dry shiner in Manhattan, and for it I took pictures of these beautiful arthritic hands caked with shoe polish.

SPECK

A Curious Collection of Uncommon Things / Peter Buchanan-Smith

84

THE RED BALLOON

THE RED BALLOON (PART II)

*Dear Speck,
On the night of the equinox, we left out food for the fairies. We carefully prepared a delicious feast consisting of apples with cinnamon, a special herb drink and dried fruits. When we would imagine our repast when we saw your balloon in its place! Love,*

Franz Kline, Untitled, Red and Brown 1960

HARRY KITT
KNOWS HOW
TO SHINE.

The variety of contributors to *Speck* helped to keep it original and interesting. The list of people included designers, a lawyer, a retired barber, curators, photographers, young children, and the people in China who printed the book.

SAHRE. I remember, when your book party happened, I was like, wait a minute, he just got out of grad school. What's going on here? It's amazing. *Speck* is basically your graduate thesis work, and getting it out into the real world is what the school was supposed to teach you, right?

BUCHANAN-SMITH. Yeah, exactly. It was really exciting to have a project of that type while I was at the *Times*. On weekends I would call people up and tell them I was from the *Times*, and they would do (almost) whatever I asked. Originally, *Speck* was meant to be a self-published journal. I met with Michael Bierut to get advice on paper sponsorship, and he suggested I make it into a book and show it to Princeton Architectural Press. I met with them, they liked the idea, and eventually agreed to publish it.

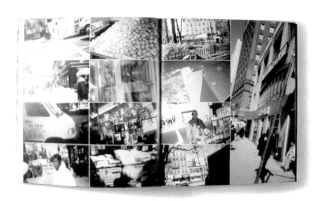

MARCH 24, 2000

86 SAHRE. Jason, your book *Sunbird* was your first foray
 into publishing. So what was the motivation here?

FULFORD. As I started arranging my images in small
 groups, I was also thinking of these small groups
 being arranged in bigger groups—as a book. I ended
 up self-publishing, because I didn't know anybody
 who would actually publish my book, and I knew it
 was going to sell slowly.

SAHRE. Maybe not sell at all?

FULFORD. Yeah, maybe not sell at all, but I didn't care. I
 had to make it. Leanne introduced me to Adam
 Gilders, a Canadian author. I started sending him pic-
 tures in the mail, and he would write back with brief
 fragments of stories. The text and the pictures began
 to play off each other. We were going after a kind of
 "hovering" quality. Adam and I edited everything
 together, and I designed the book.

 My friend Jack Woody, who publishes books of
 photography, helped us find an affordable printer in
 South Korea. We approved all of the proofs with the
 printer through the mail, and then one day a truck
 pulled up outside my house and unloaded one thou-
 sand books! As expected, *Sunbird* has sold slowly, but
 it's finally about to go out of print.

86

SHAPTON. The next book Jason and I did together was a book called *Dancing Pictures*, which is also almost out of print. We did everything on this ourselves. We shot it, designed it, and paid for the printing. The book was inspired by our habit of taking pictures of ourselves dancing.

89 This is one of the photos we took, in my kitchen in Toronto. One night at Jason's, in Scranton, we just rolled a big backdrop down, put this one Funkadelic song on repeat, and danced till seven the next morning! The camera was on a self-timer. We shot ten rolls of film before collapsing. When we got the photographs back, they were pretty funny. We thought it would be nice if we could see other people dancing to
88 their favorite music, so we put out a call for participants in Toronto and in Brooklyn. We got people to come out and bring their music—and dance.

FULFORD. In a black room. We flashed them in the dark with the music blasting!

 [laughs]

87 SHAPTON. This is the piece of paper we used to record who was dancing to what.

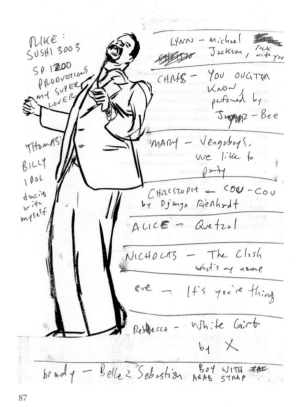

87

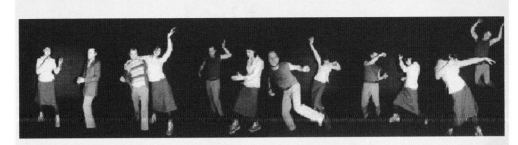

CALL FOR PARTICIPANTS

LEANNE AND JASON NEED PEOPLE WILLING TO DANCE FOR AN ART PROJECT.
REQUIRED: A PIECE OF YOUR FAVORITE DANCING MUSIC, HALF AN HOUR OF YOUR
TIME, PERMISSION TO PHOTOGRAPH YOU DANCING TO THE MUSIC (WITH US) AND
THEN PERMISSION TO PUBLISH THOSE PHOTOGRAPHS.
TIME: SATURDAY FEBRUARY THE 5TH OR SUNDAY THE 6TH.
PLEASE CALL 535-6829 TO SET UP A SESSION.
PLEASE ENCOURAGE YOUR FRIENDS TO PARTICIPATE TOO.

88

89

90 SHAPTON. This woman we never met. I think she
 heard the music and came by.
 [*shrugs*]
 FULFORD. She just e-mailed us.
 SHAPTON. Oh, did she? What was she dancing to? Her
 name was Eve.
 FULFORD. Aretha Franklin.
 SAHRE. They're all dancing to their favorite song?
91 SHAPTON. Yeah. This is Lynn, she's dancing to "Rock
 With You" by Michael Jackson.
92 This is Nicholas, dancing to The Clash.

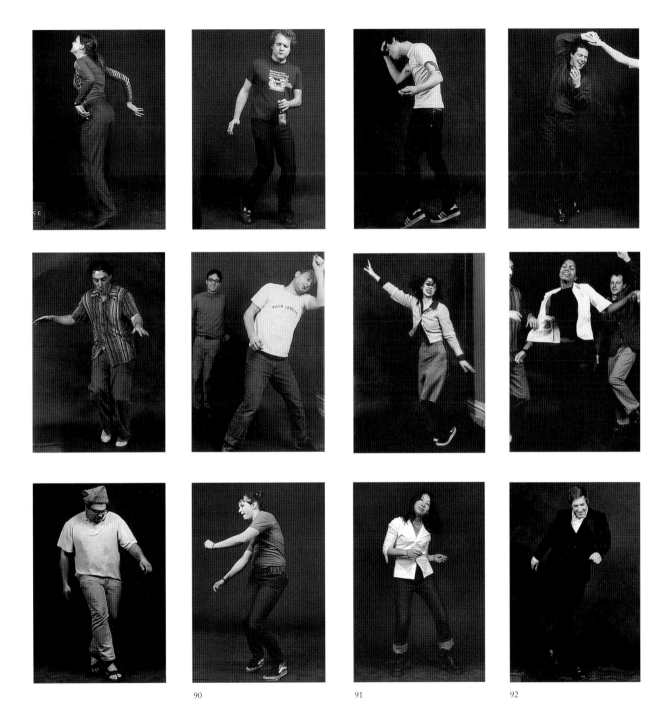

BUCHANAN-SMITH. At the same time *Speck* was being delivered into the world, Dan Nadel and I were working on a project called *The Ganzfeld*. Actually, it was called *The Ganzfeld* 2. Dan had already done *The Ganzfeld* 1 with some friends of his, as basically a zine. We wanted to make the second *Ganzfeld* bigger and better by bringing in more contributors and by improving the quality of the production as well as the distribution. We wanted a publication that more people would read.

SAHRE. Is this happening while *Speck* is also happening?

BUCHANAN-SMITH. It was all happening at the same time. *The Ganzfeld* is a book of pictures and prose, which is not based on any set themes. To some contributors (often the younger, untested ones) we give a lot of instruction when we commission their work. Other times we publish work that is already finished before we come along. Or we'll just ask people to surprise us. We don't pay anyone, so we have to be careful about being too controlling or killing pieces. The bottom line is that we want our contributors to have fun being part of *The Ganzfeld*.

　　In the second issue, some of the contributors included Renée French, Red Grooms, Maira Kalman, Richard McGuire, and Gary Panter. We gathered those guys together and had our first signing at the MoMA bookstore down in SoHo. It was a great success—we sold lots of books. This is the front of the invitation.

　　And this is *The Ganzfeld* 2, with a cover by Mike Mills.

Renée French

Red Grooms

Maira Kalman

Richard McGuire

Gary Panter

93

93

94

The covers of *The Ganzfeld* don't really reflect what's inside. Ultimately I think that readers can make their own connections here (and there are connections to be made), but there's nothing intentional. It harks back to the grand old days of George Lois and *Esquire*, where his only job was to make a cover that would sell a magazine.

95 The next images are by a great French designer, an illustrator-artist named Paul Cox. He is a self-taught artist who possesses an ideal (and I'm very envious of this) combination of design, illustration, and art skills. He's impossible to classify in this sense. He's also one of the rare artists who can create beautiful and smart images.

SAHRE. What is the nature of the collaboration between you and Dan Nadel?

BUCHANAN-SMITH. Well, we started out as me being the picture guy, while he was the word guy. He's originally an editor, and I was an art director. But in fact, we ended up overlapping in a lot of different areas. It became the ideal editor–art director relationship. At the end of the day, the only difference is that I sit down in front of a computer, putting this stuff together in Quark Xpress, while Dan is on the phone with copy editors.

97 Just this month, a year after the publication of *The Ganzfeld* 2, we've released *The Ganzfeld* 3—a takeoff from the last one and a superior product.

98 We've learned that we're not interested in repeating ourselves. We've realized that it's good to trust our

99 judgments, go with our instincts, reach for broader and more varied content, and be more playful with

100 everything—from the structure of the book down to the design of the page numbers.

95

I also think we're learning to be more stringent and selective with what we publish. I think it's safe to say that the direction will always keep changing; there's no point doing a noncommercial project like this unless you're constantly kept on your toes.

97 This is the cover for *The Ganzfeld* 3. It's weird how we get our cover ideas. We just kind of stumble over them. Dan was flipping through the *New York Times* art section one day and saw these pictures of butterflies and moths. And he said, "We've got to use this stuff!" So we used a scan of a moth that an artist named Joseph Scheer did.

96 We're also very influenced by other books— this one, *A Field Guide to the Birds* by Roger Tory Peterson, in particular, played a significant role in *The Ganzfeld* 3.

100 This is the flap of *The Ganzfeld* 3. You can see the parallels between this issue and the last.

96

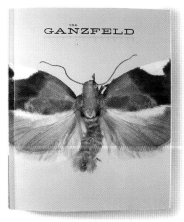

97

98

99

100

SAHRE. Leanne and Jason, J&L Publishing: What is that all about?

FULFORD. We soon realized that we were able to make books. It wasn't that difficult, and we had the tools. So we started thinking of other projects. One idea we had always talked about, for example, was mixing text and drawings together.

And I guess at this point we started saying, okay, we have a publishing company. So we're trying to think of a name for it. This was the first name: Hose and Blow. But it ended up being J&L. Our logo was designed by Paul.

SHAPTON. *J&L Illustrated #1* is the book that Jason started to describe, a combination of fiction and drawings. We put out a call to designers and artists asking them to send us drawings related to the theme of half man, half beast. We also brought on this fellow named Hunter Kennedy, who has a zine called the *Minus Times*. He edited the fiction and brought in some fantastic writers like Marc Richard, Sam Lipsyte, and Jeff Johnson.

FULFORD. We called everybody we knew, or knew about, and whose work we loved, such as David Shrigley, Paul Davis, Shary Boyle, and Marcel Dzama. We also brought in Canadian artist Jason Logan to help us commission and edit the drawings.

SHAPTON. We actually asked everybody for five bucks to submit, too. We did all the work one weekend in the *Saturday Night* editorial offices, using the scanner, the photocopier, the paper, and the printer. We wouldn't necessarily use the drawings to illustrate the stories. We would have pages and pages with images. And then, sometimes, we would have an opening spread.

101

102

The Beast is already sitting in the car when I come out of the coaches meeting. He's strumming his badminton racket like it's a guitar. He's singing along with the radio. His blonde head is bobbing up and down. I told him, twice even, that if he took the key to listen to the radio then he had to turn it to the left– all the way so as not to start the car and waste gas. But when I open the door of the rec centre the headlights are on and the engine's running. There's exhaust coming out of the tailpipe because the air is shimmering like it does when it's hot. It's late summer.

He's kind of a retard, seriously. I don't think anyone on my Dad's side thought they had it in them to produce that kind of person, but Aunt Sheila did, and there he was, since 1987, always with his mouth open in photos, always asking for unrealistic stuff at Christmas, carrying the sport and strumming it like it was a guitar. Probably one kid in a hundred thousand turns out like he did, but my Dad told me from the moment he came out

THE BADMINTON BEAST
By Craig Taylor

89

29

FULFORD. We collected drawings and stories for about a year and then, one weekend, we all met in Toronto to put it together and make it into a book.

104 SHAPTON. We printed *J&L Illustrated #1* in Iceland—not Korea—since we wanted to try out the printer that *McSweeney's* uses.

SAHRE. So now you're a company?

FULFORD. Sort of.

[*laughs*]

SHAPTON. Not for profit.

[*laughs*]

BUCHANAN-SMITH. Dan and I founded a company, too. It's called Monday Morning.

SAHRE. Now, at Monday Morning you're publishing books. But it's a graphic design studio as well, right?

BUCHANAN-SMITH. To a certain extent, yes. But Monday Morning is pretty much about publishing. In fact, I'd say we're more of an arts organization that currently concentrates on publishing and packaging books. In addition, we plan events, educational programs, and exhibits; and organize archives that center around a brand of visual culture that we feel is neglected. We envision this visual culture as a level playing field on which all boundaries are blurred between various art forms and genres. We want to bring out the similarities and differences between, for example, sign painters and gallery painters, collectors and the collected, cartoonists and cinematographers.

We design books, of course. And I have a somewhat separate career as a freelance designer doing book jackets.

This is one of our first real projects working as book packagers. One of the contributors to *The Ganzfeld* 3, Michael Benson, who lives in Slovenia, had been amassing for years these beautiful images of deep space from the NASA Web site probe photography. His theory is that these photographs are the twenty-first-century Ansel Adams. The book, called *Beyond: Visions of the Interplanetary Probes*, is going to be published by Abrams next fall. I designed it, and Dan helped edit.

105

105

FULFORD. Toward the end of my stay in Beijing, Leanne and I started toying with the idea of publishing other people's work. We found that we're interested in art and writing that carries, in equal parts, a sense of humor and the beautiful. We're drawn to artists who present these ideas in original ways. When I returned from China, we approached three young photographers whose work we admired and asked if they'd like to publish books with us.

We released these books in December 2002. The artists helped us raise the money, while Leanne and I edited and designed the books.

106

Jubilee is a collection of pictures by Ted Fair from all over the United States. I edited this selection as if it was a poem. This is a photo book that you have to "read," centering around various motifs such as rebirth, age, horses.

106

107 *Shut Up Truth* is a photo essay by Michael Schmelling about his friendship with a reclusive film projectionist in El Paso, Texas.

Most people's first reaction to this book is, "What's wrong with him?" The truth is nothing's wrong with him. He's just a dude. It's really simple.

107

108 Mike Slack found us over the Internet while I was in China. I met him on my way back, and he showed me his beautiful Polaroids. We called his book *OK OK OK*. These pictures have all the layers I was talking about earlier.

108

109 We've got some new books coming out. *Crushed* is a book about sadness and humor. I took these pictures in various countries over the last few years.

109

110 *Toronto* is a book of Leanne's drawings, which
were all made from photographs of her friends and
surroundings.

110

111 *Hey 45* is a collection of high school basketball
pictures from the *Middletown Press* (a small
Connecticut newspaper). Canadian playwright
Morwyn Brebner is writing a novella about teenage
angst to go along with the pictures. All these photos
actually ran in the newspaper. What attracted us to
them is that they all somehow incorporate failure,
pain, or an embarrassing moment.

112 Michael Lewy also found us over the Internet.
He works at Massachusetts Institute of Technology,
and in his spare time he makes these beautiful
PowerPoint charts about the everyday malaise.
SHAPTON. I think we're going to call it *Chart Sensation*.

111

CHART
SENSATION

by Michael Lewy

○ enthusiasm ○ False enthusiasm

113 Michael Northrup is an old buddy of Paul's from Baltimore. *Beautiful Ecstasy* is a book of his photographs from the '70s and '80s.

They're incredibly powerful—both emotionally and visually.

113

114 BUCHANAN-SMITH. This is another project that Dan
and I have been working on. Bill Morrison made a
film called *Decasia*, after gathering hundreds of hours
of decaying film stock—bubbling celluloid, scratchi-
ness, and all. He chopped it all up, strung it together
into a very loose narrative, and asked the composer
Michael Gordon to set a score to it. The result was a
really beautiful film. The project is up in the air right
now, but if everything works out, we would like to
sequence and edit a book about the film.

Dan and I are also working on the next issue of
The Ganzfeld, although we're not calling it *The
Ganzfeld* 4; it's going to be the art history issue.

114

SAHRE. Can you guys talk a little bit more about publishing? What is your motivation?

SHAPTON. We find that seeing a project go to press— and having it actually be produced—is just the most satisfying thing. To a certain degree we're not interested in what mainstream publishing is trying to do. I don't mean to sound deliberately marginal but we just try to make the books we want to exist.

FULFORD. We see work that's inspiring and think, "This should be a book!"

BUCHANAN-SMITH. We like the fact that we can publish a book that we so badly want to be on a bookshelf in someone's house.

SAHRE. I heard an interview with Kiss on the *Jay Leno Show*, in which he was basically saying that the reason they formed the band was because it was the band that they didn't see out there. So there you go.

FULFORD. It's also the idea of community. I think that's one of the reasons we're all publishing books. I get so restless if I stay in one place for too long. Yet it's really important as a person to have a sense of connection and comradery. Part of what we're doing is creating or fostering a network of unpretentious, talented, and energetic people who are all compelled to make beautiful things.

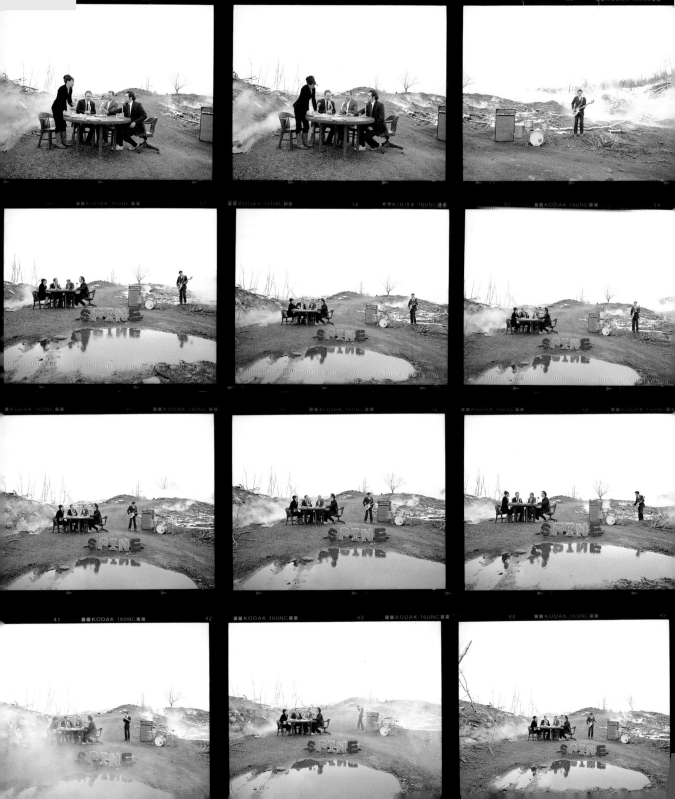

SAHRE. One of the most amazing things, I think, about the three of you is your sense of initiative—your ability to make the phone calls that you shouldn't be making, to people you have no business calling. To you it seems all very natural and seamless. "Oh yeah, I just called the publisher of Canada's largest newspaper and talked him into letting me design and have editorial control over two pages in the newspaper. No big deal."

FULFORD. Life is short. And, I don't know, I feel lucky. I feel really lucky.

BUCHANAN-SMITH. I would just get so bored and feel useless if I was not doing these things. Sort of a nervous energy. Or an insecurity or something. I have to be productive and must be calling famous people.

SAHRE. All right. Well, I'm going to close the evening with an extension of that question in a way. Here are three very young people who started their career by calling people—and now people are calling them.

SHAPTON. No one's calling me!

FULFORD. All I get is J&L e-mail.

SAHRE. No, people are really coming to you guys with ideas. Saying, please publish this.

BUCHANAN-SMITH. It's really satisfying for us to publish the work of people we find inspiring. And to meet someone who has bought one of our books— and who loves it.

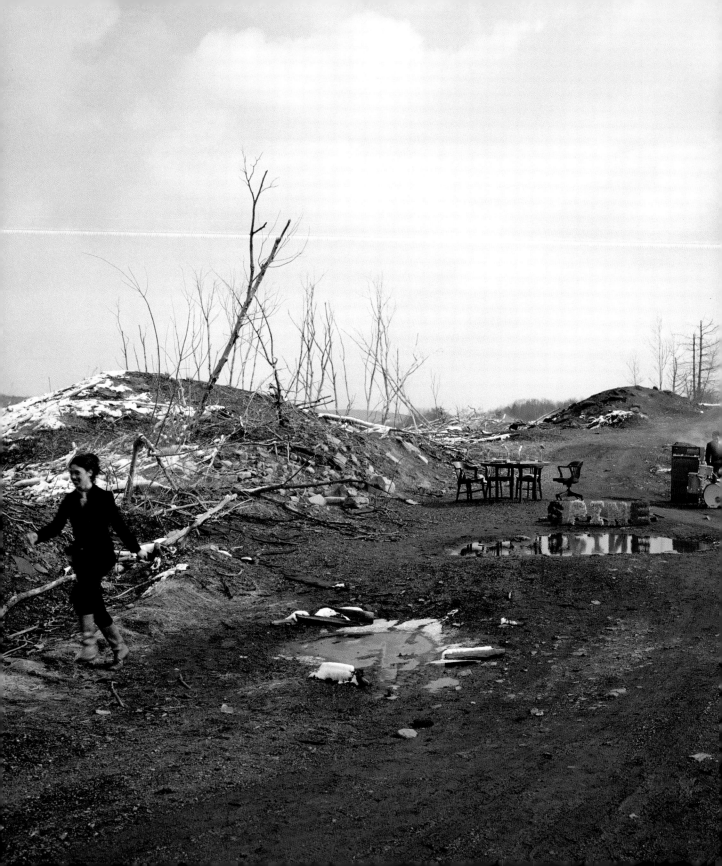

1–6: Book shelf; photograph, 2003; photographer: Jason Fulford

12–13: Spine Event at F.I.T., New York City; photographs, May 2003; photographer: Ted Fair

17: Office in Ireland; photograph, 1995; photographer: Peter Buchanan-Smith

19 (top left): *The Pleasures of the Imagination*; book case, 1997; designer: Peter Buchanan-Smith; publisher: Farrar, Straus and Giroux

19 (top right): *Keats*; book case, 1998; designer: Peter Buchanan-Smith; publisher: Farrar, Straus and Giroux

19 (bottom left): *Man is not Alone,* 1966; front matter; designer: Peter Buchanan-Smith; publisher: Noonday

19 (bottom right): *God in Search of Man,* 1956; front matter; designer: Peter Buchanan-Smith; publisher: Noonday

20–21: Missing God; sticker, 2000; designer: Peter Buchanan-Smith

22: Lawn mower race, upstate New York; photographs, 2001; photographer: Peter Buchanan-Smith

23: MTA Lost and Found; photographs, 2000; photographer: Peter Buchanan-Smith

25: *Inspiration Born of New Brain Cells,* October 1999; designer: Peter Buchanan-Smith; art director: Nicholas Blechman; publisher: *New York Times*

28: *Night Shade*; video box, 1997; designer: Jason Fulford; client: Fox Lorber Home Video

29: Natchez Trace Parkway; photograph, 1998; photographer: Jason Fulford

30–31: Contact sheet books, 1997–1999; Jason Fulford

33: Motel somewhere in Louisiana; photograph, 1998; photographer: Jason Fulford

34: *Girls, Some Boys and Other Cookies*; book by Ute Behrend, 1996; publisher: Scalo (Fulford: "My friend Mary spilled red wine on the cover.")

35: Found postcards

37: Grid of cut-up contact sheets, 1998; photographer: Jason Fulford

38: Diptych, 1998; photographer: Jason Fulford

39: Diptych, 1998; photographer: Jason Fulford

40: Diptych, 1998; photographer: Jason Fulford

41: Diptych, 2000; photographer: Jason Fulford

45: *Graphis* cover from *Revealing Illustrations* by James McMullan, 1981; publisher: Watson-Guptill Publications

46 top: Chanel No. 5; sketch, 1999; illustrator: Leanne Shapton

46 bottom: Back of girl's head; sketch, 1997; illustrator: Leanne Shapton

47 top: Girl on bike; sketch, 2000; illustrator: Leanne Shapton

47 bottom: *J'achete les lunettes…*; sketch, 1999; illustrator: Leanne Shapton

48 left: Kiss from Italian *Vogue*; sketch, 2000; illustrator: Leanne Shapton

48 right: The story of Patricia; sketch, 1997; illustrator: Leanne Shapton

49: Milan lettering; sketch, 1999; illustrator: Leanne Shapton

50: Edna St. Vincent Millay; Book Review, 2001; illustrator: Leanne Shapton; art director: Steven Heller; publisher: *New York Times*

51: Boston to Austin; Op-Ed page, 1998; illustrator: Leanne Shapton; art director: Nicholas Blechman; publisher: *New York Times*

52: *Pnin*; cover sketch, 1994; illustrator: Leanne Shapton

53 top left: *Peter Camenzind*; book jacket sketch, 1997; illustrator: Leanne Shapton; art director: Rodrigo Corral; publisher: Farrar, Straus and Giroux

53 top right: *The End of the Affair*; cover sketch, 2000; illustrator: Leanne Shapton

53 bottom left: *Beneath the Wheel*; book jacket, 1997; illustrator: Leanne Shapton; art director: Rodrigo Corral; publisher: Farrar, Straus and Giroux

53 bottom right: *The Journals of Sylvia Plath*; cover sketch, 1998; illustrator: Leanne Shapton

54: *Diary*, book jacket, 2003; illustrator: Leanne Shapton; art director: Rodrigo Corral; publisher: Doubleday

55 top left: *Catch as Catch Can*; book jacket, 2002; illustrator: Leanne Shapton; art director: Rodrigo Corral; publisher: Simon & Schuster

55 top right: *The Cyclist*; book jacket, 2002; illustrator: Leanne Shapton; art director: Paul Sahre; publisher: Simon and Schuster

55 bottom (left and right): *Diary*, book jacket proposals, 2003; illustrator: Leanne Shapton; art director: Rodrigo Corral; client: Doubleday; publisher: unpublished

56–57: Spine Event at F.I.T., New York City; photographs, May 2003; photographer: Ted Fair

59: *Love Found*; Op-Ed page, 14 February 2001; designer: Peter Buchanan-Smith (a.k.a. Angus McWilton) and Dan Nadel; art director: Peter Buchanan-Smith; publisher: *New York Times*

60: *Where is My Toothbrush*; Op-Ed page, 17 August 2001; designer: Peter Buchanan-Smith (a.k.a. Angus McWilton) and Dan Nadel; art director: Peter Buchanan-Smith; publisher: *New York Times*

61: *Eastern Parkway and Kingston Avenue, Aug. 2, 2001, 4:15*; Op-Ed page, 2001; illustrator: Lauren Redniss; art director: Peter Buchanan-Smith; publisher: *New York Times*

63: World Trade Center; Op-Ed page, 12 September 2001; photographer: unknown; art director: Peter Buchanan-Smith; publisher: *New York Times*

65: *The Reign of a Great Publisher*; Op-Ed page, 19 July 2001; photographer and art director: Peter Buchanan-Smith; publisher: *New York Times*

67: Mississippi River motorbike trip; announcement, front and back, 1998; photographer: Jason Fulford

68 top: WWF mailer, 1999; photographer: Jason Fulford

68 bottom: Christmas mailer; photographer: Jason Fulford, 1997

69 top left: Men's Body Building Competition, Beacon Theater, New York City; photograph, 1998; photographer: Jason Fulford

69 top right: Belmont Stakes, Queens, New York City; photograph, 1998; photographer: Jason Fulford

69 bottom left: Monster Truck halftime, Harrisburg, Pennsylvania; photograph, 1998; photographer: Jason Fulford

69 bottom right: Kentucky Derby, Louisville, Kentucky; photograph, 1999; photographer: Jason Fulford

70: *The Good Brother*; book jacket, 1998; designer: Archie Ferguson; photographer: Jason Fulford; publisher: Simon and Schuster

71: *The History of Western Civilization*; book jacket, 2001; photographer: Jason Fulford; designer: Paul Sahre; publisher: Touchstone

72: *Here Comes*, November 2002; photographer: Jason Fulford; designer: Stacy Clarkson; publisher: *Harper's* magazine

73 top: *What Are You Like?*; book jacket, 2000; photographer: Jason Fulford; designer: Rodrigo Corral; publisher: Atlantic Monthly Press Books

73 bottom left: *End Zone*; book jacket, 2003; photographer: Jason Fulford; designer: Paul Buckley; publisher: Penguin-Putnam

73 bottom right: *White Noise*, book jacket, 2003; photographer: Jason Fulford; designer Paul Buckley; publisher: Penguin-Putnam

75 left: *Cosmopolis*; book jacket, 2003; photographer: Jason Fulford; designer: John Fulbrook; publisher: Scribner's

75 right: *The Crazed*; book jacket, 2002; photographer: Jason Fulford; designer: Archie Ferguson; publisher: Knopf

76 top–79 top: *You Are Here*, 12 August 2002; photographer: Jason Fulford; designer: Leanne Shapton; publisher: *Saturday Night* magazine (*National Post*)

76 bottom–79 bottom: *How Far Should We Go?*, 23 February 2003; photographer: Jason Fulford; photo editor: Kira Pollack; illustrator: Nicholas Blechman; publisher: *New York Times Magazine*

83: *Columbine*; Avenue section, 12 May 1999; art director: Leanne Shapton; writers: Dan Glover, Siobhan Roberts; publisher: *National Post*

85 top left: *Boy Heroes*; Avenue section, 12 November 1999; art director: Leanne Shapton; writer: Gordon Korman; publisher: *National Post*

85 top right: *Windows '99*; Avenue section, 8 February 1999; art director: Leanne Shapton; publisher: *National Post*

85 bottom left: *Sam Donaldson*; Avenue section, 17 February 1999; art director: Leanne Shapton; photographer: Christoper Wahl; publisher: *National Post*

85 bottom right: *Remembrance Day*; Avenue section, 11 November 1998; art director: Leanne Shapton; publisher: *National Post*

87 top left: *National Funnies*; Avenue section, 18 November 1999; art director: Leanne Shapton; writer/illustrator: Seth; publisher: *National Post*

87 top right: *Thanksgiving*; Avenue section, 11 October 1999; art director: Leanne Shapton; writer/illustrator: Mary Gallagher (Dave Eggers); publisher: *National Post*

87 bottom left: *Meaning of Flowers*; Avenue section, 12 February 1999; art director: Leanne Shapton; illustrator: Emmanuel Pierre; publisher: National Post

87 bottom right: *Bookplates*; Avenue section, 22 October 1999; art director: Leanne Shapton; illustrators: various; publisher: *National Post*

89 top: Avenue October; sketch, 1998; illustrator: Leanne Shapton

89 bottom: *July*; Avenue section, 1 July 1999; art director: Leanne Shapton; illustrator: Blex Bolex; publisher: *National Post*

90: *March*; Avenue section, 1 March 2001; art director: Leanne Shapton; illustrator: Alain Pilon; publisher: *National Post*

91 top left: *June*; Avenue section, 1 June 1999; art director: Leanne Shapton; illustrator: Brian Cronin; publisher: *National Post*

91 top right: *January*; Avenue section, 2 January 2001; art director: Leanne Shapton; illustrator: Paul Davis; publisher: *National Post*

91 bottom left: *April*; Avenue section, 1 April 1999; art director: Leanne Shapton; illustrator: Benoit Van Innis; publisher: *National Post*

91 bottom right: *December*; Avenue section, 1 December 1998; art director: Leanne Shapton; illustrator: Leanne Shapton; publisher: *National Post*

93: *March*; Avenue section, 1 March 2001; art director: Leanne Shapton; illustrator: James McMullan; publisher: *National Post*

94 top: *The Big Shots*; cover, 20 May 2000; art director: Leanne Shapton; photographer: Christopher Griffith; publisher: *Saturday Night* magazine (*National Post*)

94 bottom: *When Dolphins Go Bad*; cover; 24 February 2001; art director: Leanne Shapton; illustrator: Sean Yelland; publisher: *Saturday Night* magazine (*National Post*)

95 top left: *It's Cool to be Jewish*; cover, 29 July 2000; art director: Leanne Shapton; photographer: Jelle Wagener; publisher: *Saturday Night* magazine (*National Post*)

95 top right: *Psychopaths Among Us*; cover, 8 September 2001; art director: Leanne Shapton; illustrator: David Shrigley; publisher: *Saturday Night* magazine (*National Post*)

95 bottom left: *The Love and Marriage Issue*; cover, 26 August 2000; art director: Leanne Shapton; illustrator: Nicholas Blechman; publisher: *Saturday Night* magazine (*National Post*)

95 bottom right: *What's a Wife Worth?*; cover, 12 May 2001; art director: Leanne Shapton; illustrator: Barbara Kruger; publisher: *Saturday Night* magazine (*National Post*)

96 top: Bathing suits; style page, 3 June 2000; art director: Leanne Shapton; illustrator: Filip Pagowski; publisher: *Saturday Night* magazine (*National Post*)

96 bottom: Sunglasses; style page, 24 April 2001; art director: Leanne Shapton; photographer: Paul Graham; publisher: *Saturday Night* magazine (*National Post*)

97 top left: cover; *Saturday Post*, 3 November 2001; art director: Leanne Shapton; illustrator: James McMullan; publisher: *National Post*

97 top right: cover; *Saturday Post* fashion section, 4 May 2002; art director: Leanne Shapton; illustrator: Paul Davis; publisher: *National Post*

97 bottom: Mesh; style page, 29 July 2000; art director: Leanne Shapton; illustrator: Philippe Weisbecker; publisher: *Saturday Night* magazine (*National Post*)

98–99: Spine Event at F.I.T., New York City; photographs, May 2003; photographer: Ted Fair

100: *Speck*; book cover, 2002; designer/author: Peter Buchanan-Smith; publisher: Princeton Architectural Press

101 top left and right: *Red Balloon* (from *Speck*); photographer: Daniel Taylor; publisher: Princeton Architectural Press

101 middle left: *Backs of Paintings* (from *Speck*); photographer: Adam Yates; publisher: Princeton Architectural Press

101 middle right: *Lipstick* (from *Speck*); photographer: Stacy Greene; publisher: Princeton Architectural Press

101 bottom left: *The Found Alphabet* (from *Speck*); photographer: Amy Unikewicz; publisher: Princeton Architectural Press

101 bottom right: *Harry Kitt Knows How to Shine* (from *Speck*); photographer: Peter Buchanan-Smith; publisher: Princeton Architectural Press

103 top left: *Inspected by Tags* (from *Speck*); from the collection of: Ron Barrett; photographer: Peter Buchanan-Smith; publisher: Princeton Architectural Press

103 top right: *Earth, Air, and Water* (from *Speck*); from the collection of: Eddie Simon; photographer: Peter Buchanan-Smith; publisher: Princeton Architectural Press

103 middle left: *Recycled Paper* (from *Speck*); photographer: John Willis; publisher: Princeton Architectural Press

103 middle right: *Sight Seeing* (from *Speck*); photographer: Cyrus Habib; publisher: Princeton Architectural Press

103 bottom left: *March 24, 2000* (from *Speck*); designer: Angela Reichers; publisher: Princeton Architectural Press

103 bottom right: *The End Papers* (from *Speck*); designer: Steven Guarnaccia; publisher Princeton Architectural Press

104–105: *Sunbird*; interior pages, 2000; photographer: Jason Fulford; writer: Adam Gilders; publisher: J&L

106: Notepaper; illustrator: Leanne Shapton

107 top: Call for Participants, 1999; photographers: Jason Fulford and Leanne Shapton; designers: Jason Fulford and Leanne Shapton

107 bottom: Jason and Leanne dancing in her kitchen, 1999; Photographer: Leanne Shapton

109: *Dancing Pictures*; interior images, 2001; photographers and designers: Leanne Shapton and Jason Fulford; publisher: J&L

110: *The Ganzfeld* signing at MoMA, 2002; designer: Peter Buchanan-Smith; publisher: Monday Morning

111 top: *The Ganzfeld* 2, cover, 2002; designer: Peter Buchanan-Smith; artwork: Mike Mills; publisher: Monday Morning

111 middle: *Popeyeandolive* (from *The Ganzfeld* 2); designer: Richard McGuire; publisher: Monday Morning

111 bottom: *Wallpaper Guide: "Ganz Girls"* (from *The Ganzfeld* 2); illustrator: Ron Rege, Jr.; publisher: Monday Morning

112–113: *My Story* (from *The Ganzfeld* 2); illustrator: Paul Cox; publisher: Monday Morning

114: *A Field Guide to the Birds*; book by Roger Tory Peterson, 1934; publisher: Houghton Mifflin Co.

115 top left: *The Ganzfeld* 3; cover, 2002; artwork: Joseph Scheer; designer: Peter Buchanan-Smith; publisher: Monday Morning

115 top right: *Canon* (from *The Ganzfeld* 3), 2002; author: Rick Moddy; illustrator: Fred Tomaselli; publisher: Monday Morning

115 middle: *Hairy Who's History of the Hairy Who* (from *The Ganzfeld* 3), with Hairy Who Poster (Hyde Park Art Center), 1966; author: Dan Nadel; publisher: Monday Morning

115 bottom: *The Ganzfeld* 3; endpapers; designer: Peter Buchanan-Smith; publisher: Monday Morning

116 top: Hose and Blow; first idea for J&L's
 company name
116 bottom: J&L logo, 2002; designer: Paul
 Sahre, 2002
117 top left: *J&L Illustrated #1*; cover, 2001;
 illustrator: Leanne Shapton; publisher:
 J&L
117 top right: *J&L Illustrated #1*; inside illustra-
 tion; illustrator: Jason Logan; publisher:
 J&L
117 bottom: *J&L Illustrated #1*, inside illustra-
 tions; illustrators: Dame Darcy and
 Gary Clement; publisher: J&L
119: View of Reykjavik, Iceland, 2001; photog-
 rapher: Jason Fulford
120–121: *Beyond: Visions of Interplanetary
 Probes*, 2003; designers: Michael
 Benson, Peter Buchanan-Smith; pub-
 lisher: Harry N. Abrams
122–123: *Jubilee*; cover and interior images,
 2002; photographer: Ted Fair; designers:
 Jason Fulford and Leanne Shapton;
 publisher: J&L
124–125: *Shut Up Truth*; cover and interior
 images, 2002; photographer: Michael
 Schmelling; designers: Jason Fulford
 and Leanne Shapton; publisher: J&L
126–127: *OK OK OK*; cover and interior
 images, 2003; photographer: Mike
 Slack; designers: Jason Fulford and
 Leanne Shapton; publisher: J&L
128–129: *Crushed*; interior images, 2003; pho-
 tographer: Jason Fulford; designers:
 Jason Fulford and Leanne Shapton;
 publisher: J&L
130–131: *Toronto*; interior images, 2003; illus-
 trator: Leanne Shapton; designers: Jason
 Fulford and Leanne Shapton; publisher:
 J&L
132: *Hey 45*; cover and interior pages; writer:
 Morwyn Brebner; photographs from
 The Middletown Press, Middletown,
 Connecticut; designers: Jason Fulford
 and Leanne Shapton; publisher: to be
 published by J&L, 2004
133: *Chart Sensation*; cover and interior pages,
 2003; author: Michael Lewy; designers:
 Jason Fulford and Leanne Shapton;
 publisher: J&L
135: *Beautiful Ecstasy*; interior images, 2003;
 photographer: Michael Northrup;
 designer: Paul Sahre; publisher: J&L

136–137: *Decasia*; images: Bill Morrison;
 designer: Peter Buchanan-Smith; art
 directors: Peter Buchanan-Smith, Dan
 Nadel; publisher: unpublished
139, 141: Spine poster outtakes, 2003; photog-
 rapher: Gus Powell